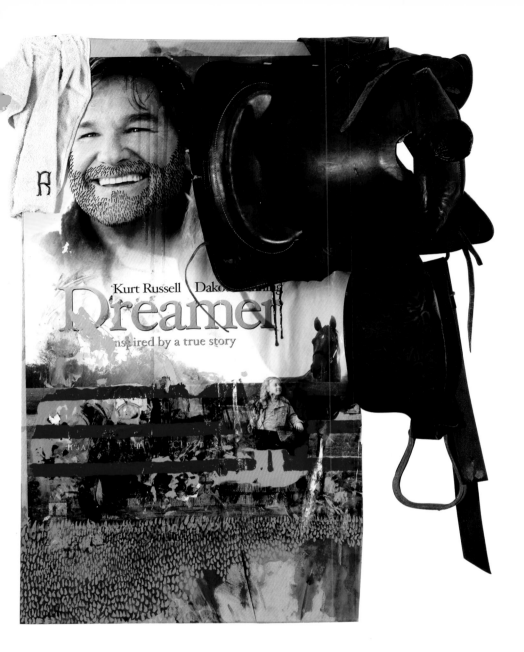

DREAMER, 2007

Justin Lieberman

Marc Jancou Contemporary, New York
Zach Feuer Gallery, New York

"A PLACE FOR EVERYTHING AND EVERYTHING IN ITS PLACE"
2007

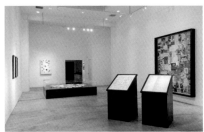

A Place for Everything and Everything in its Place is a sculptural installation based around two large collages made from found photos, lottery tickets, personal snapshots, small drawings and watercolors, newspaper and magazine clippings, and documentation and leftover scraps from previous projects. A black and white diagram drawing of the 291 separate elements of this collage, and a hand-written key to this diagram, are presented under the slanted glass surfaces of two wooden podiums similar to those found in a natural history museum. The smaller collage is a roughly circular arrangement that has been assembled to resemble a random pile on a wooden plinth. The accompanying diagram and key for this collage are hung on the wall.

In the diagram keys, I attempted to take an objective stance, labeling the fragments as though I had no personal relationship to them. I soon found that this was impossible, as many of them would have had to remain nameless were it not for my personal relationship to them. So I began to write of myself in the third person, a pretension usually associated with actors on talk shows or artists writing their own press releases. However, in recounting the histories of certain scraps included in the collage, I sometimes found that even this "fake third person" was insufficient to express the reason that a piece of paper was in my possession and thus found its way into the collage. Looking back over my attempt at "objective" labeling of scraps of paper from my life that for some reason managed to avoid the wastebasket, I find that I am oddly prone to indignant ranting and gloating over trivial matters, revealing my own subjectivity at every turn. And so the installation *A Place for Everything and Everything in its Place* became a kind of diaristic exercise rather than my original intention: a formal and conceptual framework to act as a repository for the detritus of my everyday existence.

—JUSTIN LIEBERMAN, EXCERPTED FROM THE PRESS RELEASE OF THE EXHIBITION

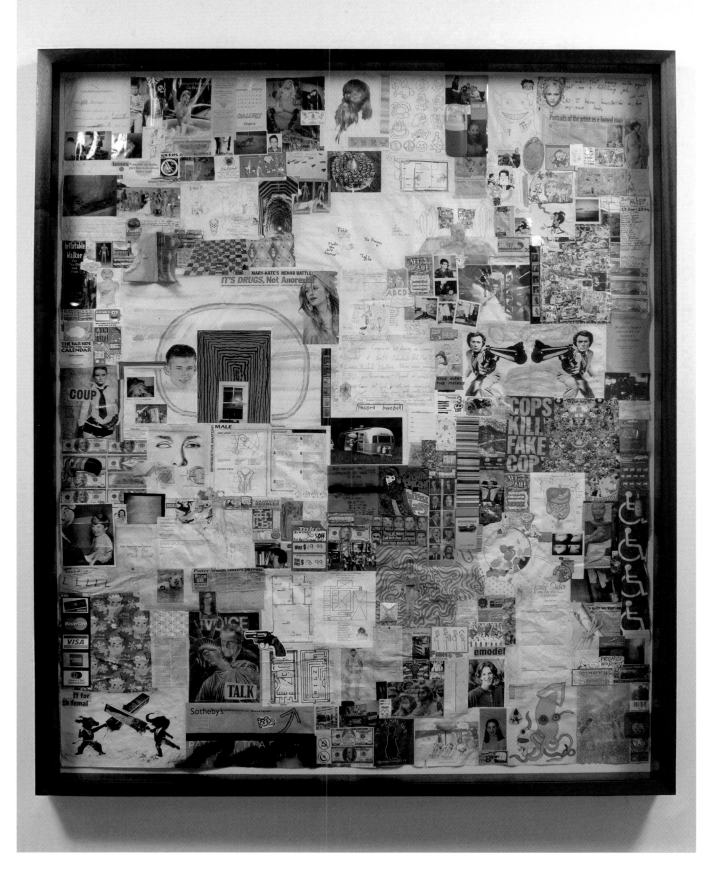

"AGENCY: OPEN HOUSE"
2007

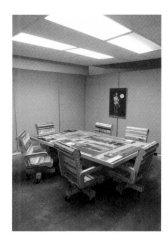

Some texts relating to the exhibition
Agency: Open House

Our Mission

Q: Why does advertising target the young and mock the elderly?
A: Because even death is preferable to life in a broken body.

We are an independent, creatively-led advertising agency that exists to create strong and provocative relationships between good companies and their consumers. Our key strength is brand building. We find the cultural truths about—or intersections between—product, consumer and business.

Both Andy Warhol and Joseph Beuys were originally engaged in a form of radical democratization. Beuys' model originated in the aftermath of trauma and some forms of religious substitution, if not attempts at redemption. Warhol's, by contrast, took its point of departure from the populist utopianism delivered in America by commercial design and consumer culture. These are two very contradictory approaches, yet both concretize the very structures in which most of us have experienced secularization, democratization, and the semblance of equality in the last few decades.

More recently, the globalization of corporate commodity culture has created a marketplace that many artists feel compelled to deal with directly in their work. But as Benjamin Buchloh has pointed out, this subject is a minefield. *Agency: Open House* is meant to lie somewhere between the calculated polish and ironic complicity of Takashi Murakami, and the material poverty and uncompromising refusal of Thomas Hirschhorn.

We specialize in understanding cultural trends. As a result, we have made brands influence our culture. Once brands are accepted on this level, they are infinitely more powerful. We work in all media, including broadcast, print and online.

When I was 8 years old, the parents of one of my friends owned a video camera. My friend and I would make commercials for real products on this camera, aping the language of advertising that we heard on TV. Sometimes the commercials were satirical, sometimes they were in earnest. We didn't really distinguish between one and the other.

"Wacky Packages" were a series of editorial trading cards featuring parodies of consumer products. The cards were produced by the Topps Company beginning in 1967, usually in a sticker format. The original series sold for two years, and the concept proved popular enough that it has been revived a few times since. The cards spoofed well-known brands and packaging, such as "Blisterine" (instead of Listerine) and "Neverready" batteries (for Eveready batteries).

The initial series was followed by a somewhat different "Wacky Ads" line in 1969. These cards were designed more like miniature billboards with a die-cut around the parodied product, so it could pop out of the horizontal billboard scene.

Even in the current international marketplace, New York still qualifies as the Hollywood of print media, and one of my goals here was to participate in, rather than mock or critique, that culture.

—JUSTIN LIEBERMAN, EXCERPTED FROM THE PRESS RELEASE OF THE EXHIBITION

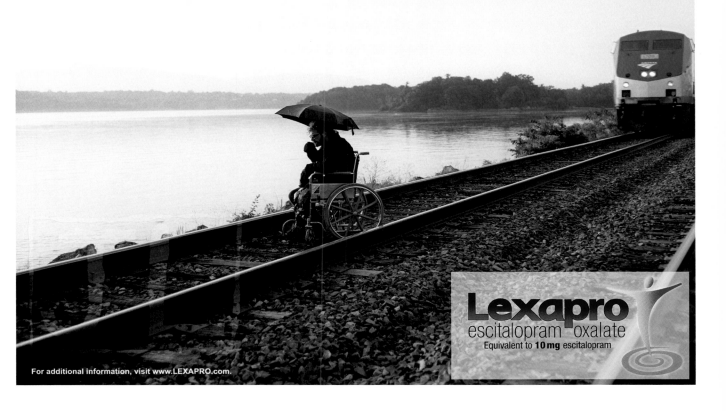

DON'T LET IT COME TO THIS.

Lexapro
escitalopram oxalate
Equivalent to **10 mg** escitalopram

For additional information, visit www.LEXAPRO.com.

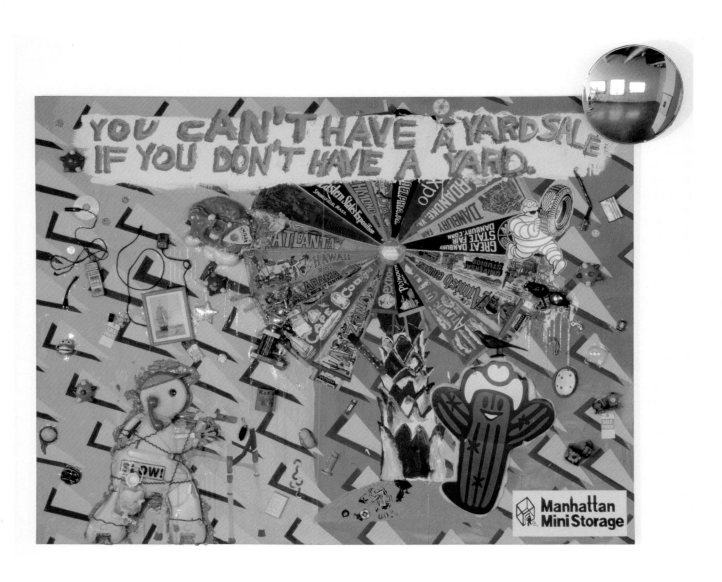

"CULTURAL EXCHANGE"
2006

The artistic globalism of the early 1990s (and as it continues on today) is based on a classical idea of nomadism as it was developed by Gauguin but in a more politically correct form. The contemporary global nomadic artist utilizes the materials and techniques of the locale in which he or she temporarily resides in an attempt to avoid portraying the culture as the exotic other. Dave Hickey rightly typifies the contemporary nomadic artist as a biennial-hopping bricoleur, well-adapted to an artistic climate that privileges "site-specific, regional artworks theoretically informed by a critical rhetoric that insists upon the primacy of the local, the imperatives of group identity, and the ineluctable logic of historical necessity."

Nomadism as it exists today is predicated on an economic power base that far exceeds that of most landowners. As a contemporary lifestyle, it has little or nothing in common with its egalitarian roots.

And so for the *Belgian Cultural Exchange*, I chose not to abandon the site-specific installation, but rather to acknowledge its elitist underpinnings and attempt to defy its current politically correct and self-satisfied condition. By taking on the role of the "Ugly American" (which I am) and displaying only the limited and popular aspects of the place, I hope to envision a new global nomadism based on the experience of the contemporary tourist, whose limited income coincides with cheap plane tickets and a superficial knowledge of his destination.

—JUSTIN LIEBERMAN, EXCERPTED FROM THE PRESS RELEASE OF THE EXHIBITION

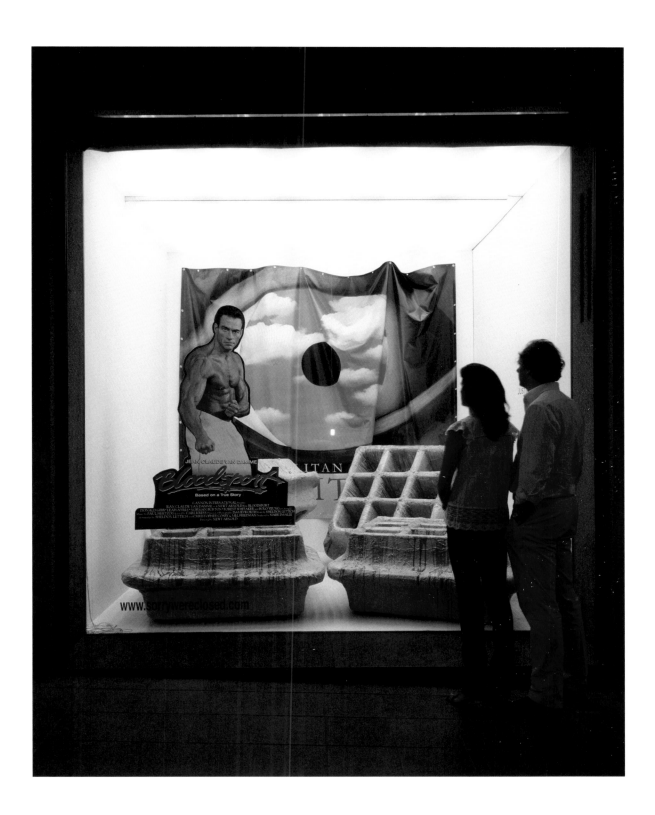

Installation view, CULTURAL EXCHANGE, Sorry We're Closed, Brussels, 2006

"EBONY, IVORY, RUBBER & DOUGH"
2007

 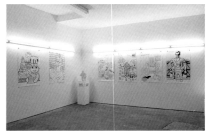

In William Gibson's 2003 novel *Pattern Recognition*, his female protagonist Cayce Pollard has a violent physical reaction to images of the Michelin Man, which cause her to break out in hives. My own initial reactions to the Michelin Man as well as the Pillsbury Doughboy were not unpleasant, but similarly intense. From my earliest childhood, I can recall harboring a deep and abiding affection for the characters. For some time I even had a plush doughboy which I slept with at night.

Ebony, Ivory, Rubber & Dough is both an anthropologic/curatorial fantasy and a structuralist installation that utilizes the Pillsbury Doughboy and Bibendum, the Michelin tire man, as an entry point to create various polemical aesthetic associations between blacklight painting, coloring book illustration, the American popular grotesque, and fascist aesthetics and imagery. The 16 paintings and 4 sculptures in the exhibition can be grouped into 4 categories:

1. Early and/or grotesque blacklight representations of the Pillsbury Doughboy

2. Early and/or threatening blacklight representations of Bibendum

3. Later/cute "white light" representations of the Doughboy

4. Later/cute "white light" representations of Bibendum

This "cuteness development" is a reality of the characters' history and can be traced to the influence of Japanese cartooning, the enlargement of eyes and heads in proportion to bodies being a key factor.

While blacklight painting is a traditional medium whose history is primarily associated with the use of psychedelic drugs and 1960s counter-culture, the designation of the other works in the exhibition as "white light" is entirely my own. They are paintings designed to look like coloring book illustrations, and are intended as a "good" counterpoint to the "evil" blacklight works.

It is interesting to note that grotesque representations of the Pillsbury Doughboy are very much in abundance, while unauthorized depictions of the Michelin Man are relatively hard to come by. Perhaps it is the former's unrelenting cheerfulness that inspires people to take up their pens against him.

Concerning the fascist blacklight representations of Bibendum: when Bibendum was first conceived, the aesthetics that determined his design were, like Futurism, very much a product of the industrial revolution. The dark optimism of early images of the Michelin Man now seems as though it could not but be related to the fascist aesthetics of Albert Speer, and indeed they are cousins of a sort. Speer drew heavily on advertising for his designs. This resulted in a kind of transposing of public perception over time: much of the advertising imagery of the machine age now seems to have an ominous tone that is difficult to distinguish from the one evoked by Nazi imagery and propaganda.

Of course, the overarching controversy in this exhibition lies in the contrast between its structuralist mode of presentation and its fantasy/historical approach to its subjects. This approach is not without its own history. Fan art and literature has always consisted of a mix of the fantastic and the historical. Much like the further adventures of the *Star Wars* characters or the volumes devoted to those of Tolkien's stories, *Ebony, Ivory, Rubber & Dough* presents a bit of atavistic arcana from its characters' case histories.

—JUSTIN LIEBERMAN, EXCERPTED FROM THE PRESS RELEASE OF THE EXHIBITION

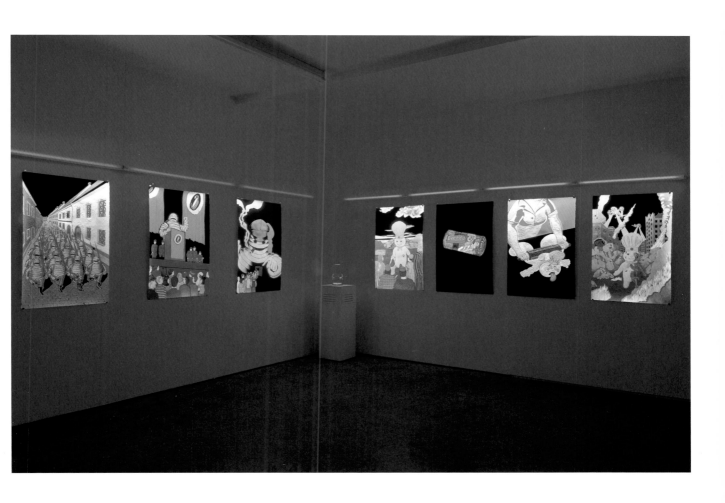

13

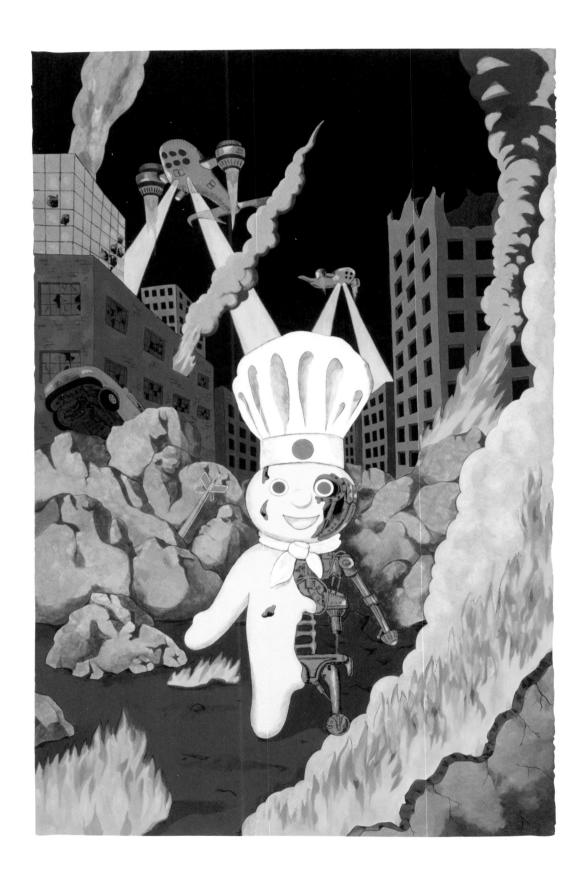

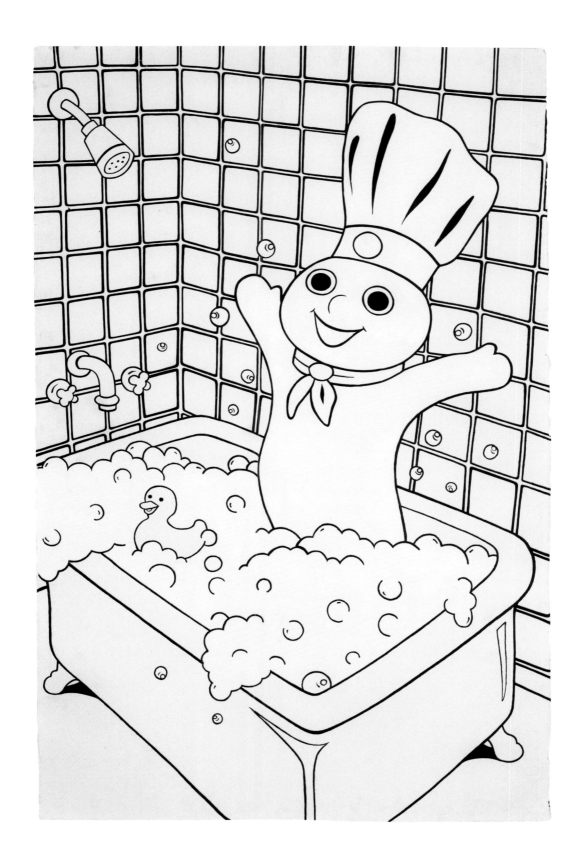

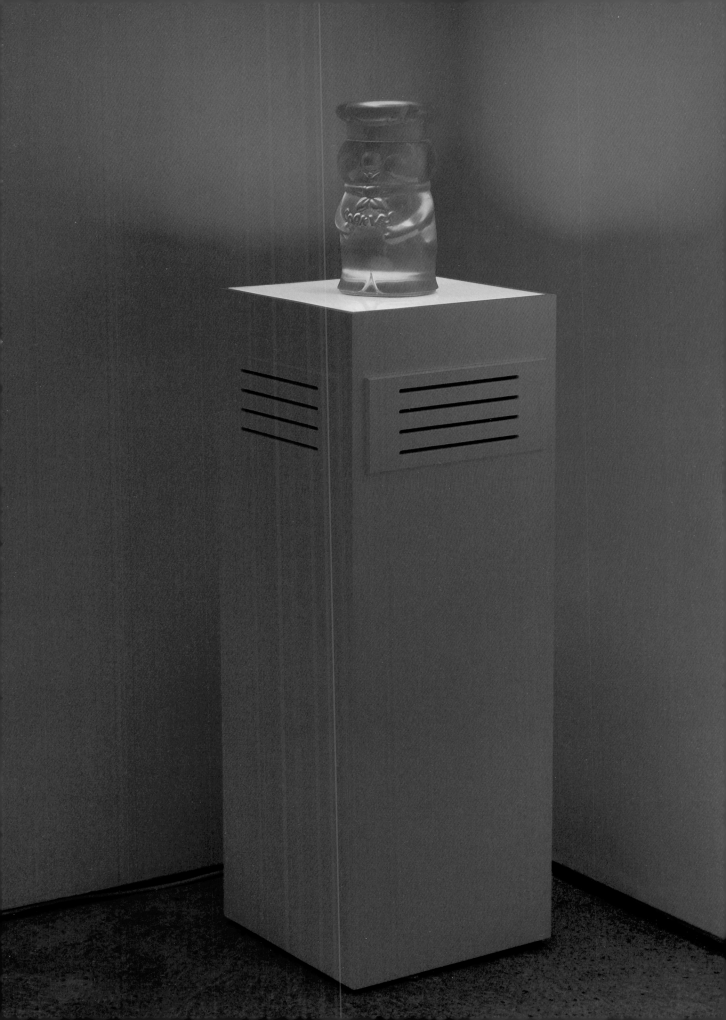

"FAMOUS ALIENS OF FILMLAND & AMERICAN FOLK FURNITURE ORIGINALS BY JUSTIN LIEBERMAN"
2008

I got the idea for the *Famous Aliens of Filmland* paintings from a tiny painting of Kurt Russell that I bought on eBay and used as part of a sculpture I exhibited in Geneva. It was listed as a "REAL PAINTING!!! NOT A PRINT!!! HAND-PAINTED!!!!" In fact though, it was a photograph that had been altered in Photoshop to look like a painting (a very simple procedure) and then made into an inkjet print on canvas.

The inkjet painting with its false front of authenticity is clearly a degraded product, yet extremely effective in its illusionism. It is a trompe l'oeil painting of a painting in which the haptic, textural qualities of painting function as a carrier of authenticity. They are installed in aluminum and Plexiglas "community boards," which are framing devices traditionally used to house a rotating series of bulletins, advertisements, awards, and art projects in high schools and office buildings.

The furniture pieces primarily consist of yard sale items that have been refurbished and altered in my studio, and refer to a tradition of folk furniture practiced in the Appalachian region where I grew up. The inherent use value of furniture relegates it to the lower status of "merely design" while increasing its appeal as a commodity to a much wider audience than that of the "fine arts." This is why a connoisseurship based on appreciation of expression of unique individual genius disdains these utilitarian objects. But in this case, it is the furniture that bears the artistic virtue of an iconoclastic individualism and the paintings that refer to design in their ways and means of mass production. It is a reversal that highlights the issues of class and morality that form the basis of aesthetic judgment.

—JUSTIN LIEBERMAN, EXCERPTED FROM THE PRESS RELEASE OF THE EXHIBITION

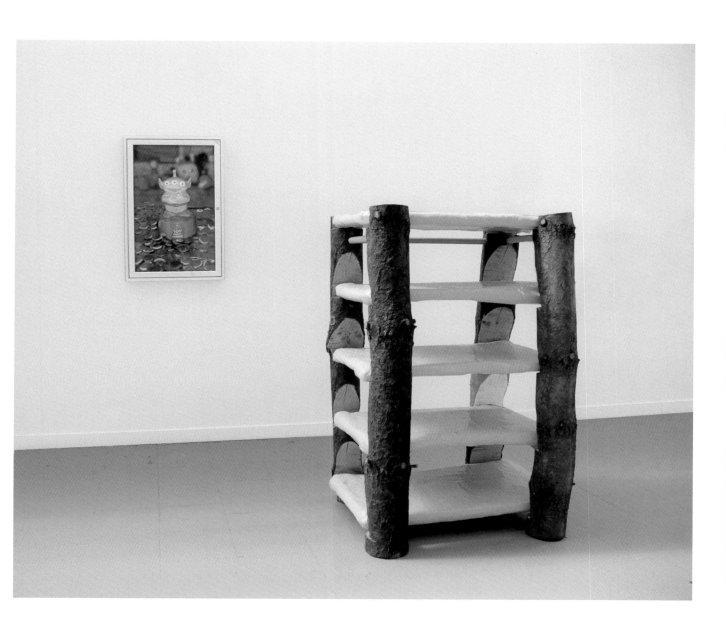

FLINTSTONE-STYLE STEREO SHELVING UNIT AND TOY STORY ALIEN CERAMIC BANK, 2008

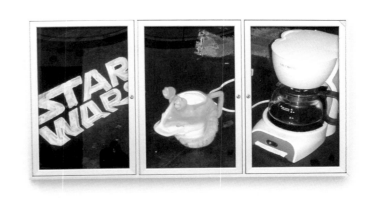

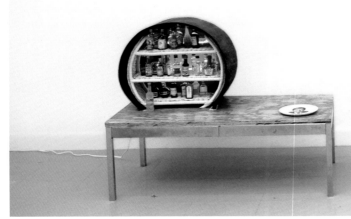

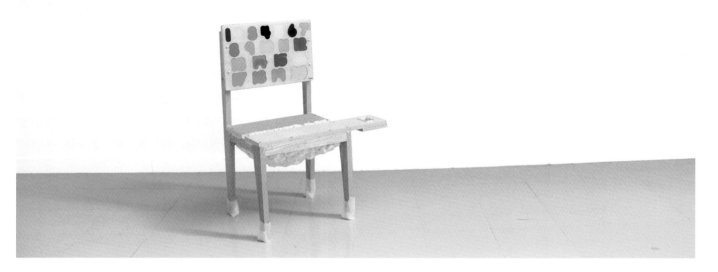

LEARNING AID CHAIR AND HAND-PAINTED GIZMO FIGURINE, 2008

"FAN FICTIONS AND ANAGLYPHIC WORKS"
2008

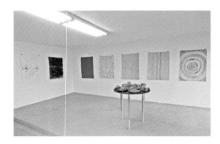

In introducing the works for this show, I would like to begin with a bit of history. I had made two *Rocket Car Glue Dream* sculptures and had quite a few rockets left from the original flea market purchase. The first two sculptures were supposed to be the kind of wacky result of model building, in which the builder has been overcome by the fumes from the glue he is using to build the models, and begins to free associate. In this one though, I decided to think more about the science-fiction aspect of model spaceships and built a kind of "super rocket." Really just a lot of rockets attached together. I made an *Outer Space* painting for it as a kind of backdrop. In a way, that piece is what led me to the works in this exhibition, entitled *Anaglyphic Drawings and Fan Works*.

There was a simplicity to the final rocket sculpture that I was at first uncomfortable with: I was worried that it was merely a formal junk sculpture. But on further consideration, I realized that the formalism in the piece had been directed towards an almost illusionistic effect, which is a significant departure for me. This illusionism seemed to be in the service of creating a believable fantasy of outer space travel: the dilapidated spaceship, the glimmering textured surface of the painting that represented the stars, the drama of the spaceship's pose, etc. It struck me that there is a warped logic in placing an illusionistic fantasy in a context where the unspoken rule is one of an object's own self-recognition. The classic example would be a painting that is highly aware of its own existence and status as an object, with the attendant Greenbergian truth to materials. What could be more perverse in regards to this rule than a completely illusionistic scene painting, a window into an imaginary fantasy world?

And so I decided to create the two giant *Fan Paintings* for this show in Gstaad. I have returned to the notion of Fan art several times over, but never in so explicit a form as these two paintings. The first, *Emperor Letoseid Atreides II and the Challengers of the Unknown*, posits a combination of two characters from science-fiction: Darkseid, arch nemesis of Superman, and Duke Leto Atreides II, God Emperor of Arrakis, also known as Dune. The second, *Red Son of the Scrith,* is set in Larry Niven's *Ringworld* and combines an already hypothetical version of Superman as a Communist hero with Niven's famous alien, the Peirson's Puppeteer envisioned as a member of the Green Lantern Corp. Fan fiction as a rule has a very narrow audience, and rarely aspires to a larger one. Only those both familiar and obsessed with the original works will fully understand the events and juxtapositions set out by the avid fan. They are intended for initiates. This is particularly interesting to me within the context of monumental paintings, which generally propose a universality that stands outside of all cultural contexts, yet they most often utilize highly codified visual systems of abstraction whose meanings are inaccessible to the layman viewer. The two forms are both diametrically opposed and perversely similar.

The *Anaglyphic Drawings* are related to the fan fictions but only tangentially. They come out of my recent preoccupation with the idea of novelty, both in the sense of the "novelty item" as a cheap gag object, and in the sense of the ever present hunger for the shock of the new. Anaglyphic optical effects, more commonly referred to as 3-D effects, were widely used in the cinema and comic books for a brief period of time in the late 1950s and early 1960s. The use of red and blue lenses, and corresponding red and blue "shadows" offset to the right and left of the primary image, created an extremely primitive three-dimensional effect in which characters and objects appeared to be projecting out of the page or screen. However, the red and blue lenses required to experience the effect often produced little more than a headache. My own anaglyphic works fall into two categories: abstract works on paper made with craft materials, and a single sculpture, *Anaglyphic Product Array*, a conglomeration of red and blue household items.

—JUSTIN LIEBERMAN, EXCERPTED FROM THE PRESS RELEASE OF THE EXHIBITION

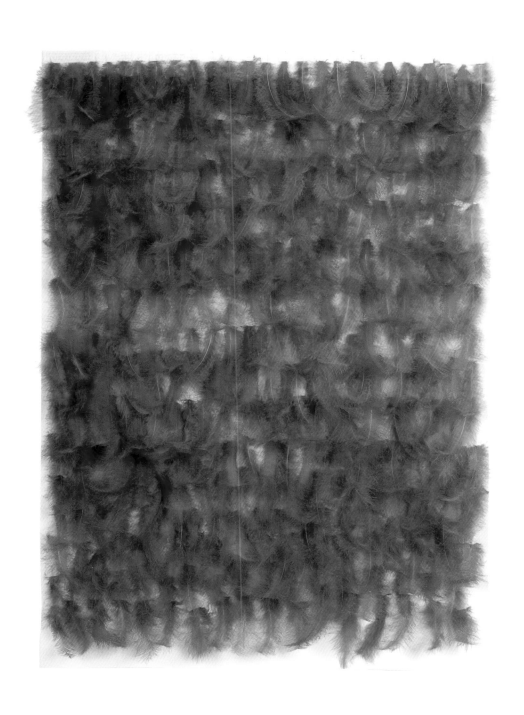

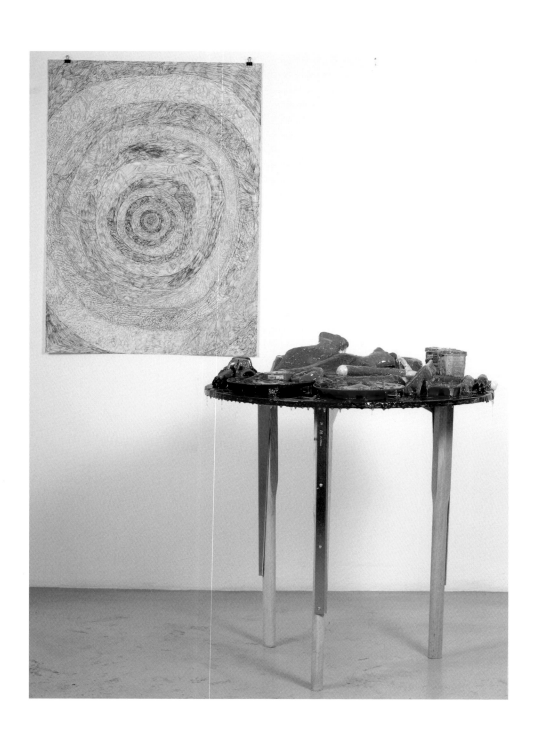

ANAGLYPHIC DRAWING AND PRODUCT ARRAY, 2008

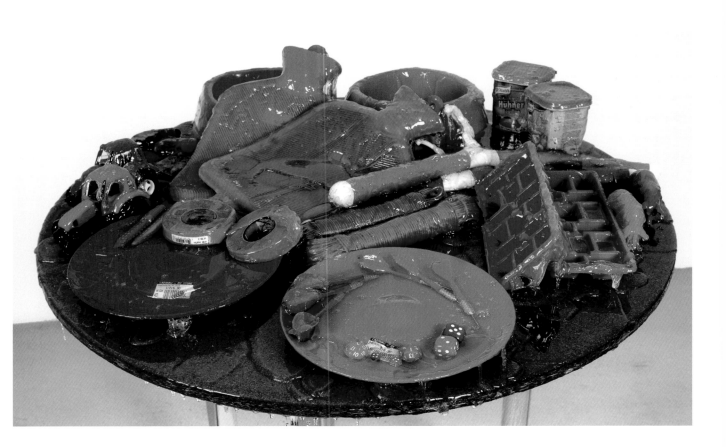

Detail of ANAGLYPHIC DRAWING AND PRODUCT ARRAY, 2008

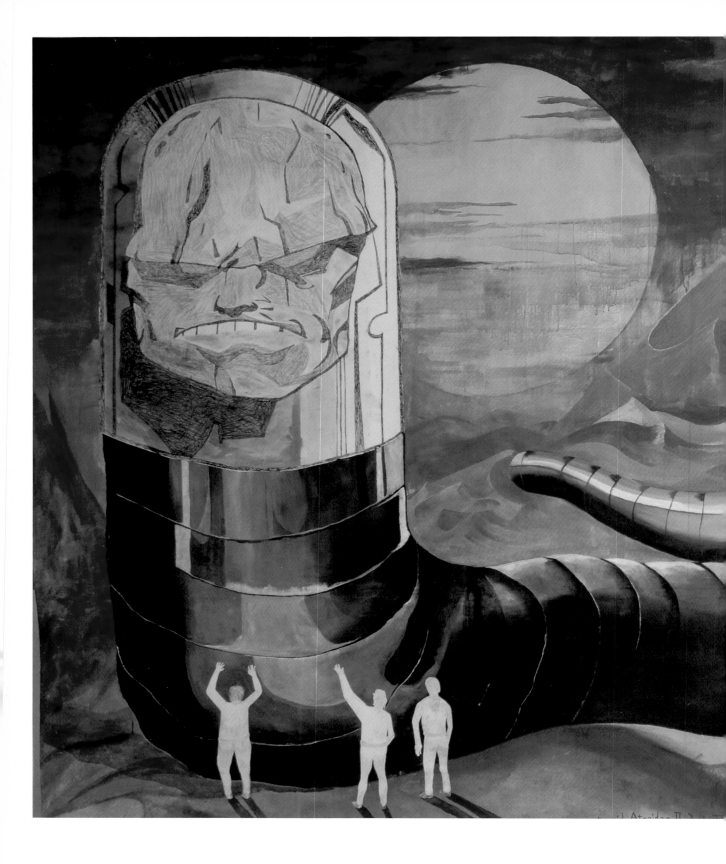

EMPEROR LETOSEID ATREITES II AND THE CHALLENGERS OF THE UNKNOWN, 2008

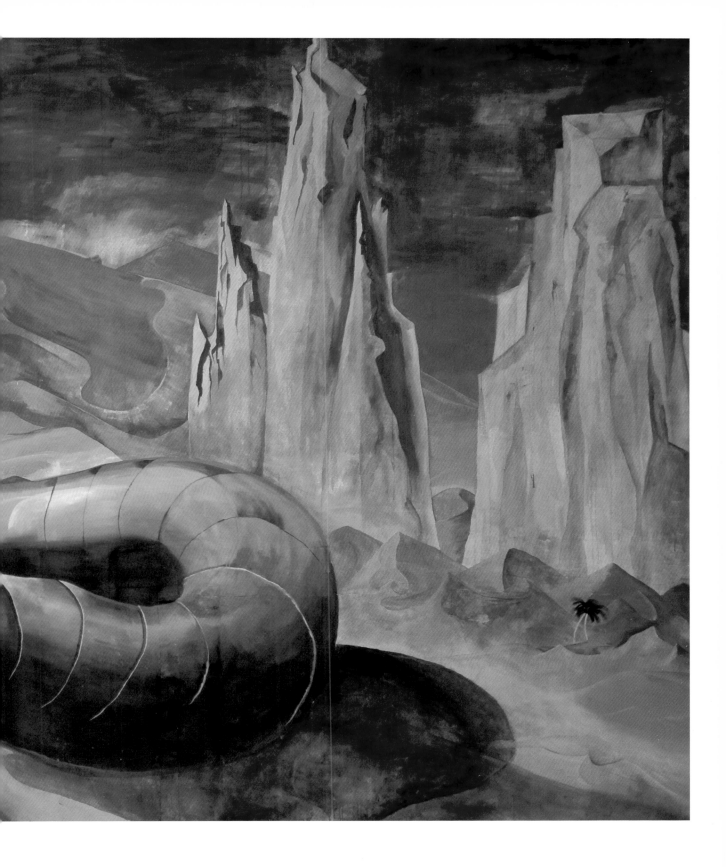

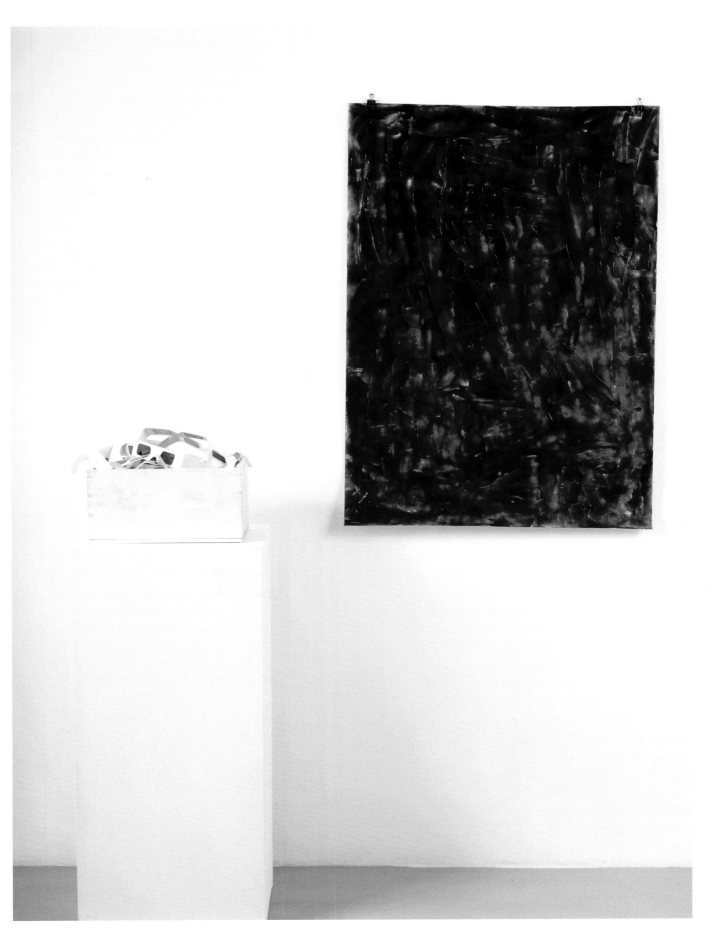

ANAGLYPHIC MICRO-OPTICAL BLEND, 2008

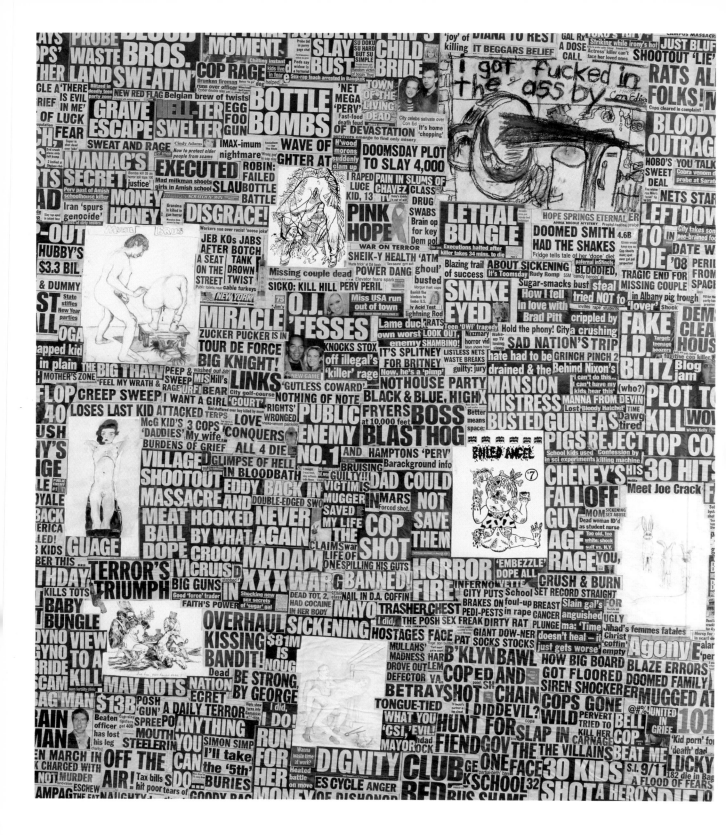

Lieberman is…
Catherine Taft

As "Stuntman Mike," Kurt Russell wears tight jeans, leather wristbands and a silver racing jacket branded with Icy Hot logos. His thick hair is feathered and swept back from his boxy face, which is marked by a deep vertical scar cutting down the left cheek. At the local roadhouse, Gueros, "Stuntman Mike" sloppily eats nachos, impersonates John Wayne, and gets a lap dance from a young Texan in flip flops. He leaves the bar with a blonde and loads her into his black 1970 Chevy Nova decorated with a skull and lightning bolt cross-bones. He reassures the blonde that the car is "death proof," but she doesn't survive. Before the night is over, four more women, including the lap dancer with the flip flops, are also killed by "Stuntman Mike" and his de ath-proof weapon, the Chevy Nova.

Quentin Tarantino's 2007 film *Death Proof* was an attempt to revive, or perhaps invoke, Kurt Russell's hyper-masculine, cinematic immortality through "Stuntman Mike." Although Tarantino is skilled at orchestrating these sorts of movie comebacks (take David Carradine in *Kill Bill* for example), Kurt Russell's apotheosis as a cult icon remains dubious. Nevertheless, the stunt that Tarantino did pull off was to bring Kurt Russell back into the popular consciousness at an unexpected (and otherwise uncalled for) moment. Throughout his acting career—from adolescent gigs on *The Wonderful World of Disney* through his made-for-TV biographies, forgettable comedy roles and occasional action flicks of the 80s and 90s—Russell has wrestled with his on-screen image, his scattered successes, and his somewhat anemic public persona. In short, the movie-going public has simply forgotten about him. And while Russell's mediocre career trajectory may seem like a questionable subject of scrutiny, it is a matter that Justin Lieberman has earnestly undertaken with the diligence of an archivist, the fixation of an anthropologist, and the prudence of a market researcher.

Lieberman's 2007 installation *Kurt Russell: RE-GENESIS* (first exhibited at Kavi Gupta Gallery, Chicago, June 29–August 11, 2007) is a thorough assessment of the actor's hodgepodge of roles and slow move towards "cult" status. The series consists of twelve paintings (which Lieberman began before the theatrical release of *Death Proof*), each incorporating a movie poster from a Kurt Russell film. Collaging, painting and defacing their surfaces, Lieberman worked each poster into an assemblage that was aesthetically guided by the respective movie's plot (as the artist could remember it) or by the poster's dominant design motif (when the artist hadn't seen the movie). Thus, a poster for *Overboard* (in which Russell plays a blue-collar handyman who falls for an upper class woman with amnesia) is festooned with a hammer and pliers. A poster for *Dreamer* (in which Russell, as a down and out horse trainer, overcomes great odds

with a retired race horse) is affixed to canvas, wrapped with a leather saddle, and painted with broad grass-green brushstrokes.

When exhibited together, these discrete paintings were accompanied by a single sculpture positioned at the center of the gallery: *Quentin Tarantino's Death Proof* (2007) is a pedestal-like form covered in posters and promo cards from *Death Proof* and surrounded by promotional items—hats, lunchboxes, posters, a flask, a T-shirt, publicity stills—scattered on the ground. Atop the pedestal sit a pair of model cars custom-painted by the artist to replicate the 1970 Chevy Nova and the 1969 Dodge Charger used in the film. This altar to slick merchandising, infused with macho Americana and B-movie tropes, might pretentiously signify some sort of collective death drive in the American psyche. Alternately, it might serve as a stand-in for Kurt Russell himself, a public persona totaling the sum of the useless commodities he inspired. But Lieberman's approach to *Quentin Tarantino's Death Proof* is something far more straightforward in relation to the paintings; this form is a central barometer within a logical and spatially organized system that charts a set of data, in this case, Kurt Russell's rise to cult celebrity.

Lieberman likens the installation of *Kurt Russell: RE-GENESIS* to a three-dimensional bar graph, with the paintings usefully charting which films contributed to the actor's "rebirth" in *Death Proof*. Various lengths of wooden stretcher bars hold each painting away from the wall at a distance in relation to the adjacent sculpture. In this way, paintings about movies that had little to do with the formation of Kurt Russell as a cult hero are mounted close to the wall, while those that fueled Russell's cult status are suspended furthest away from the wall as if reaching towards *Quentin Tarantino's Death Proof*. For example, *Big Trouble In Little China* (2008)—an expressionistically painted poster for the movie of the same title that is cluttered with kitschy Chinese trinkets—protrudes four feet away from the wall at a relational distance that represents Russell's memorable performance, the kind that would thrust him closer to cult status in popular opinion.

As an empirical array of information, this approach is quite effective, but doubtless it can leave the viewer asking: "Why Kurt Russell?" Lieberman's fascination with Russell can be traced to his interest in the mechanics of cult iconology, its relation to camp sensibility and the potential of fandom as an analytical tool.[1] But on a more basic level, it may simply be that this actor's particular history of ambiguous failure and success was too ripe not to be contained and diagrammed (if only for the sake of containing and diagramming). Underlying much of Lieberman's practice is a rigorous adherence to and performance of structuralism. In this sense, *Kurt Russell: RE-GENESIS* is less about Kurt Russell (and even less about painting, pop art or American movie culture) than it is about organizational systems. As Lieberman explains, "My work deals with the aesthetic and logical structures of the various institutions of taste it inhabits, both physically and virtually. So, for example, when creating a sculpture that deals with an organizational system for Beanie Babies, the issue at hand is not the subversion of the

1
Lieberman's interest in Russell has extended into other artworks and exhibitions. A version of the installation *Kurt Russell: RE-GENESIS* was included in the group exhibition, *In Geneva No One Can Hear You Scream* at Blondeau Fine Art Services, Geneva, Switzerland, in March of 2008. Unlike the solo exhibition of the same title, this presentation included two additional paintings including a small, faux painting of Kurt Russell that the artist found on eBay. This found painting then became the impetus for Lieberman's series *Famous Aliens of Filmland and American Folk Furniture Originals by Justin Lieberman*, which was exhibited at Galerie Rodolphe Janssen, Brussels, Belgium, May 23–July 19, 2008.

world of fine art by introducing mass marketed consumer collectibles, but the subversion of traditional structures already in place for the preservation and display of Beanie Babies."[2] In this respect, the literal structures (the wooden bars and poster surfaces) of Lieberman's Kurt Russell paintings become formal expressions of a greater structure of meaning, the "institution of taste" within which a movie star might exist.

Lieberman has long employed this sort of methodology, which in past bodies of work has played out through the recognizable systems of advertising, furniture design, outsider art, home shopping television, art conservation, corporate franchises, and taxonomic display, to name a few. The latter was efficiently demonstrated in the exhibition *A Place for Everything and Everything in its Place* (at Kantor/Feuer Gallery, Los Angeles, January 20–March 3, 2007), a show that emulated the prosaic design parameters of museology by containing a flux of capitalist odds and ends. This series consists of four sizeable collages that incorporate receipts, counterfeit dollars, lottery tickets, magazine clippings, found photos, sketches, and public signage, among other debris. Presented under thick glass vitrines, each arrangement is accompanied by a hand-drawn and numbered key that cataloged the origins of the remnants; two of these informative drawings take on a pathetic sculptural "authority" when placed atop wooden podiums resembling those commonly found in public repositories. In the diptych, *Elective Affinities with Monochromatic Color Average Shift* (2007) a large collage of art world ephemera, like gallery announcements, fliers, and magazine ads, is hung next to a nondescript, geometrically abstract painting. Echoing the collaged composition, the canvas reduces the array of printed matter to a patchwork of monochromatic rectangles, a move that mimics the didactic institutional impulse while making relics of both painting and the art market.

Like most objects subsumed by "the institution," these works move between preciousness and sterility, a conflict that is inherent in the installation of *A Place for Everything and Everything in its Place*. The contrived objectivity of the museum's system of display is at constant odds with the subjective "natural history" that slips into the work via Lieberman's textual descriptions and scrappy, autobiographical leftovers. He explains, "I attempted to take an objective stance, labeling the fragments as though I had no personal relationship to them. I soon found that this was impossible though, as many of [the fragments] would have had to remain nameless were it not for my personal relationship to them. So I began to write of myself in the third person... However, in recounting the histories of certain scraps included in the collage, I sometimes found that even this 'fake third person' was insufficient to express the reason that a piece of paper was in my possession and thus found its way into the collage... And so the installation became a kind of diaristic exercise rather than my original intention: a formal and conceptual framework to act as a repository for the detritus of my everyday existence."[3] In attempting to construct an objective "place" for the material evidence of his own life, Lieberman becomes subject to the very rules, guidelines, systems and instructions that he orchestrates

2
In conversation with the artist via e-mail, September 15, 2008.

3
Exhibition statement for *A Place for Everything and Everything in its Place*, Kantor/Feuer Gallery, Los Angeles, CA, January 20–March 3, 2007.

for external materials or ideas. Turning an already self-imposed structure onto the self, he begins to lose control, yielding to language; the naming of things; the telling of stories rather than the building of concrete frameworks.

Lieberman frequently builds for himself a prison-house of narrative, that is, an inescapable system or scenario in which art making might occur. These fixed narratives are a sophisticated method for defining art making, but they aren't necessarily essential to the meanings of the resulting objects, which tend to formally surmount notions of "plot." Nevertheless, a number of Lieberman's works originate as fictional (but not unlikely) narratives that the artist enjoys telling himself and his viewers. *Box of Money* (2005), for example, a cardboard box brimming with poorly Xeroxed dollar bills, sprang from the hypothetical story of an inept teenage counterfeiter whose second-rate ersatz currency has been seized by the government.[4] The *Rocket Car Glue Dream* (2008) sculptures were conceived of as the "wacky result of model building in which the builder has been overcome by the fumes from the glue he is using and he begins to free associate."[5] The "models" end up resembling twinned phalluses dripping with an icy ejaculate and set against an indiscriminately montaged space backdrop.

The artist's latest body of work, *The Corrector in the High Castle* (2008), is quite possibly Lieberman's most complex interpretation of narrative to date. The installation's source material is not a story of the artist's invention, but rather Philip K. Dick's 1962 novel, *The Man in the High Castle*. As revisionist historical fiction, the novel's involved, jingoistic storylines offered Lieberman possibilities for creating a complete sculptural mise-en-scene. Consequently, *The Corrector in the High Castle* materialized as the apartment of one of the story's characters, a Japanese collector (the "Corrector," a name that plays with the stereotypes of Japanese-to-English translation) of "American (and occasionally European) pop cultural artifacts who is afflicted with a severe case of neotoma. His collections of comic books, newspapers, VHS cassettes, records, Beanie Babies, lunchboxes, baseball cards, toys and other ephemera are piled everywhere, and like the Corrector himself, seem to be frozen in amber."[6] Lieberman describes how this inhabitant placates his desires for constant material gain by fabricating homemade "placeholder" objects, which allow his collections of like things to appear whole and complete even if they are not. These DIY collectables lay bare the cultural slips between real and artificial, original and reproduction. The "placeholder" for the Gutenberg Bible, for example, is a lumpy form cast in resin and awkwardly hand-painted to resemble the original. It is less than a forgery, but not quite an independent interpretation of the original. As compulsive objects, these "placeholders" substantiate their fictional maker's abnormal conduct, namely the hoarding behavior associated with neurological trauma. These notions of order, disorder, ritual, obsession, collecting, and cultural byproducts become material characters in and of themselves.

While Lieberman allows such complex stories to direct his conceptual approaches to art making, he's also not afraid to let narrative, or even

4
Exhibited in *Time and Money* at Sutton Lane, London, UK, March 23–April 23, 2005.

5
Exhibition statement from *Fan Fictions and Anaglyphic Works*, Patricia Low Gallery, Gstaad, Switzerland, August 2–28, 2008. This story eventually became the catalyst for Lieberman's recent *Fan Fictions* series (2008).

6
In conversation with the artist via e-mail September 2, 2008.

the idea of communication, devolve into "lower" forms of language. For even a debased language is a useful one. The artist admits, "Looking back over my attempt at 'objective' labeling of scraps of paper from my life that for some reason managed to avoid the wastebasket, I find that I am oddly prone to indignant ranting and gloating over trivial matters, revealing my own subjectivity at every turn."[7] That Lieberman's naming of objects, as in *A Place for Everything and Everything in its Place*, can give way to an impulsive rant reveals that his process is one of negotiating predefined structure and spontaneous action. Accordingly, the "rant" might be the most appropriate way to describe the artist's practice.

As a vehement kind of speech that is clumsily situated between *la langue* and *la parole*, a rant is a half-breed of lucid meaning and unintelligible utterance. As a rant draws from both fact and unproven claims to defend or attack an idea or institution, so do Lieberman's installations make their points by pulling together recognizable, but often mismatched forms. His 2003 sculpture, *Klansfriends*, for example, a pair of stuffed cushion figures that embrace with pillow arms, harangues the cultural attitudes of hippies and the Ku Klux Klan through an unmistakable use of tie-dyed bodies and pointed hood-like heads. Lieberman's objects and images shift between such references and signs as if to confront structure and destruction, meaning and its messier manifestations. *The Corrector in the High Castle* is a material rant that might be compared to a bipolar episode; its seemingly arbitrary referents attempt the composure of formalism (the melancholy) but are ultimately consumed by the mayhem of expressionism (the mania) as objects are scattered over cabinets and racks, shellacked in an all-consuming resin, and replicated through pathetic attempts at authenticity.

Lieberman will be the first to admit that the items amassed for *The Corrector in the High Castle* are essentially junk, the kinds of mass produced and cast-off things that can forever be salvaged at flea markets or second hand stores. As the casualties of fashion's unrest, these populist artifacts hold within them the histories of their own degradation, the upshots and punch lines of shifting human tastes. Although they are hopelessly futile timecapsules, Lieberman recognizes their usefulness in destabilizing cultural systems, confusing the rules, and obscuring the lexicons; in his hands, Beanie Babies have the potential of a semantic system and Kurt Russell can become some hoary indexical sign. Through the process of stockpiling and classifying such common objects, the artist at once negotiates and negates the value of the "collectable" while subverting the structures of collection and display. And in Lieberman's dejected taxonomies, junk becomes a broken language —objectified statements, rants and figures of speech—and its presentation, an oblique and unreliable meaning.

7
Exhibition statement for *A Place for Everything and Everything in its Place*, Kantor/Feuer Gallery, Los Angeles, CA, January 20– March 3, 2007.

"FOLK ART IS THE WORK OF SATISFIED SLAVES"
2004

I: Let's begin with the idea of the gag or one-liner. Your work seems to contain references to these in some way.

J: Definitely. I'm very interested in the concept of the "little idea" and its ability to evade essentialism.

I: The specificity of the subjects you choose also has to do with that.

J: Art is the only mode of communication in which ambiguity is considered a virtue. Spoken, written, and visual language like signs or advertising, all attempt to maintain clarity as a rapport with the viewer.

I: But art's function is not so clearly defined.

J: For me, the one-liner functions as a stepladder to its own implications, which can be manifold. In the same way that a joke provokes different reactions based on the context in which it is told. Different people's reactions are descriptive of both the joke and themselves.

I: Some of your works seem to exhibit a sort of manic tone, of having been created in a frenzy.

J: Yes, but I feel that it is a sublimated one.

I: There is a tension between the labored, almost amateurish look of the work's execution and the relationship of the subject to its presentation, which is always geared to elicit a very specific response.

J: The way an object is made has a great deal to do with the way in which it is read. I find that objects with a certain mix of attention to detail and denial of traditional craft are read more sympathetically.

I: Are you trying to elicit sympathy from the viewer?

J: Not exactly. I see the crudity of certain objects as being at odds with the things that they are saying. It is a contradiction that can take on different meanings depending on the subject. The evidence of its origin as handmade also provides an entry point into the work. A socialized veneer.

I: And once I have entered the work through this somewhat formal means, the deciphering of intention becomes pleasurable. It's a very different approach than the traditional avant-garde tactic of taking an overtly hostile stance in relation to the viewer.

J: Dada was a movement that took great pleasure in cursing its audience. Cy Twombly is an artist whose early works have become emblematic of that approach in respect to painting. While I certainly identify with both Dada and Twombly, I don't think that type of work could possibly be as effective today.

I: The use of appropriation in your work contains vestiges of that hostility.

J: Many artists of my generation employ appropriation without making it a central or even peripheral issue in the work, unselfconsciously using material (especially cartoons) that they feel close to or grew up with. Most of the time the elements are combined in an intuitive manner rather than a critical one and the combinations are based on information that is usually irrelevant to the work itself. I see this type of work as a form of expressionism because its use of appropriation is related to subjectivity and personal perception. Left in the hands of critics, a connection is inevitably drawn to the collapse of private and public formation of identity. It's a formula for the criticism of this work that has been endlessly repeated. "The artist as DJ, sampling bits of visual information and combining them into a kind of cultural bricolage." I can't even remember how many times I've heard that phrase.

I: How does your own use of appropriation differ?

J: I use appropriated material to point to some sort of idea that is intrinsic in the material itself. Usually something that was hidden is made explicit. For instance, in *Dead Kennedy's Coffee Table*, the DK logo is used as a symbol of punk politics and radical ideology. Through its transformation into a bourgeois luxury item it depicts the failure of those politics and ideology. Similarly, the idea of art is degraded by its transformation into furniture. It becomes merely applied art. Those things were already there. They aren't new ideas.

I: All of these psychological games with the viewer seem tied to the performative. For instance, in *The Pleasure Principle*, I feel as though I myself am being implicated in the work, merely through the act of looking.

J: That piece was meant to make the viewer more keenly aware of the expectations he or she brings to an artwork. There is a long history of this sort of transgression in art, currently exemplified by artists like Larry Clark and Nan Goldin. Artists are expected to live in the gutter and report back on its conditions to a cultured elite. But there's a catch. The artist must maintain a certain amount of distance from this degraded lifestyle, at least in the works themselves, so as not to alienate his viewer completely. By placing myself at the center of a predictable example of bohemian transgression, my aim was to highlight the banality of this exchange.

I: Much of your work seems to deal with failure. Do you see the works themselves as failures?

J: I see art itself as a failed enterprise. Failed in its attempt to communicate or to elevate the human spirit. Transgression once fulfilled this need in art, but now transgression is impossible. All that is left are little games to be played out with art of the past.

—JUSTIN LIEBERMAN, EXCERPTED FROM THE PRESS RELEASE OF THE EXHIBITION

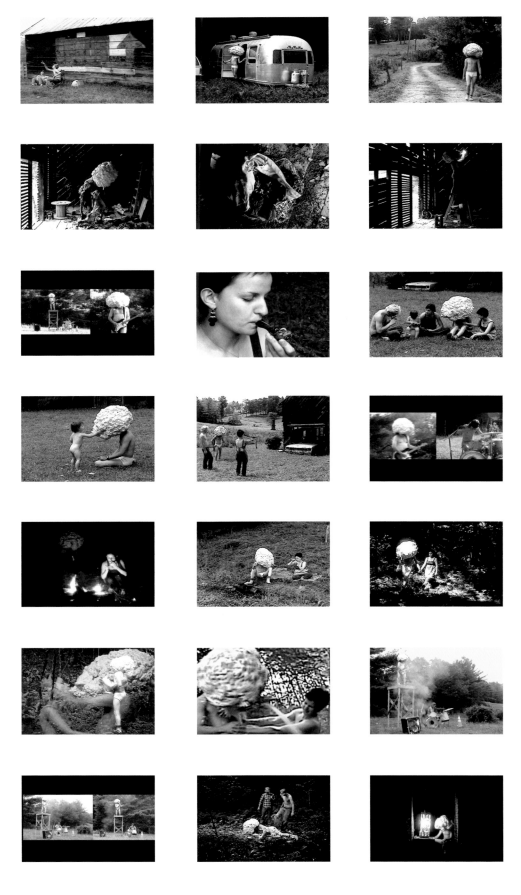

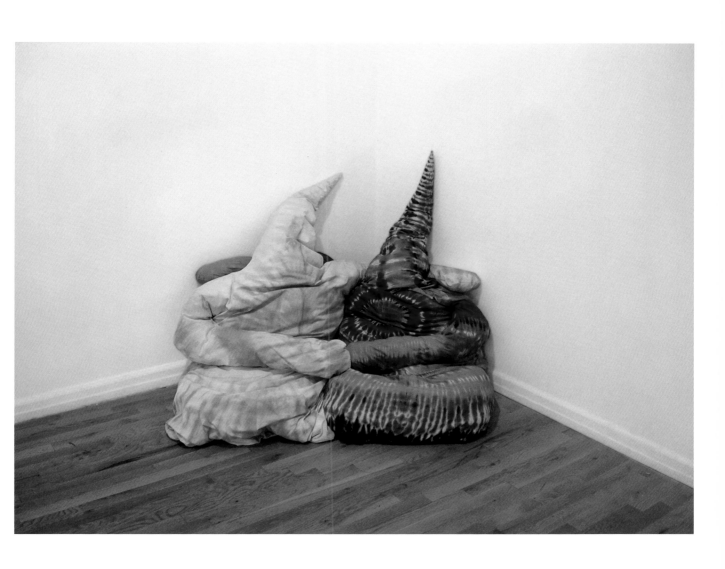

"KURT RUSSELL: RE-GENESIS"
2007

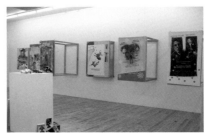

Kurt Russell: RE-GENESIS
A Topographic Exhibition Exploring the Mechanics of
Cult Iconology

Never having played a defining role in a series
of successful films, Kurt Russell was kept from
parlaying his on-camera identity into an iconic
public image, in the way that William Shatner or John
Travolta have managed. In general, the phenomenon
of the cult icon is one that stems primarily from gay
culture and its tradition of camp. A cult iconology of
the ultra-masculine has something perverse about
it to begin with, because the very notion of the cult
icon is inherently tied to the aesthetics of camp,
and its subtle reversals of gender-roles. In a way,
the idea of the cult icon has its roots in the idea of
the *gay* icon, a role for which Kurt Russell seems
to be ill-suited. To my knowledge, it would seem
that Russell's recent film, *Death Proof* by Quentin
Tarantino, is one of the only films that practices
this sort of cult-revival in mainstream film, although
a similar casting occurred in Matthew Barney's
Cremaster 3, in which the sculptor, Richard Serra,
is treated as a sort of hyper-masculine cult icon.
The sculpture depicting *Death Proof* represents
Russell's "re-genesis": his re-birth as a cult icon,
and the paintings depict the winding celluloid road
that led him there.

—JUSTIN LIEBERMAN, EXCERPTED FROM THE PRESS RELEASE OF
THE EXHIBITION

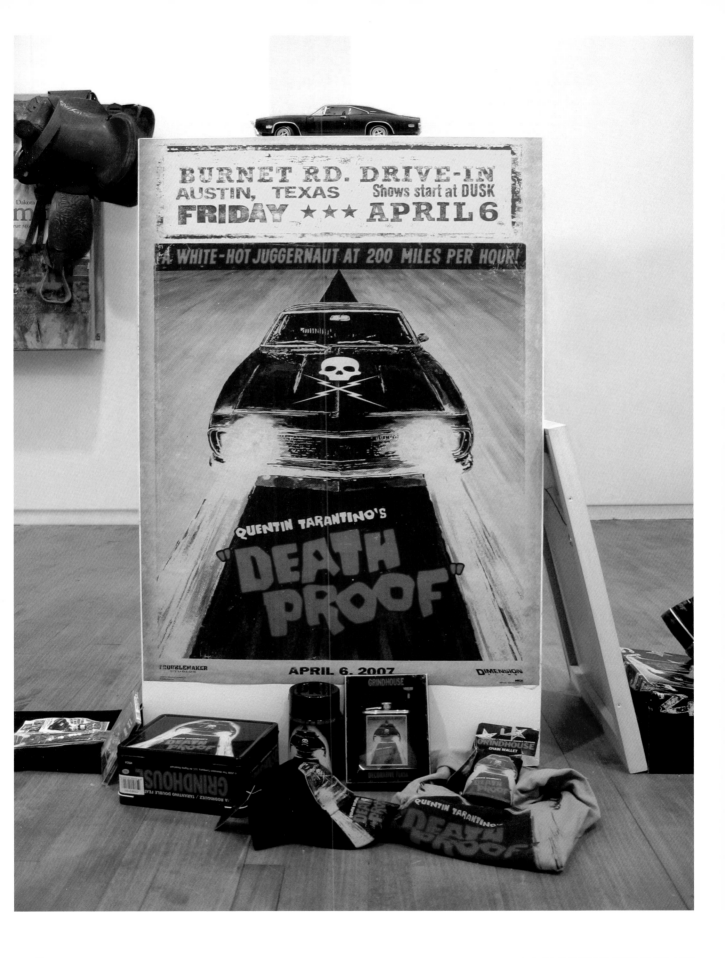

"GRAND OPENING!!!"
ST. BARTH
2006

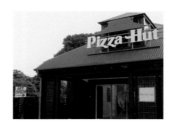

The following is an extract of a conversation between Marc Jancou and Justin Lieberman regarding the exhibition *Grand Opening!!!* at Me.di.um, St. Barth.

Marc Jancou: A Pizza Hut seems particularly out of place in St. Barth. What did you have in mind?

Justin Lieberman: It first occurred to me when I saw a picture of the gallery, which is topped with a red peaked roof, which I thought was very strange for an art gallery. It immediately reminded me of a Pizza Hut. It was only later that I realized most of the buildings on the island have these roofs. So it became a kind of transformation of the island's architectural landscape. By naming one, you kind of name them all.

Jancou: Did you have problems with local zoning boards?

Lieberman: When you don't ask permission, nobody can say "no." Of course there are strict regulations concerning chain stores and their signs on the island. Cartier and Louis Vuitton are allowed, K-Mart and McDonald's are not. So there is a democratic component as well. Why should the rich be the only ones to benefit from the corporate commercialization of the island?

It kind of refers back to the anti-corporate sentiments of "culture jamming," a term and practice I usually can't stand. Like when someone takes a corporate logo and turns it into something that criticizes the corporation. Most of it is hopelessly idealistic and righteous, as well as didactic in an extremely formulaic way. With the Pizza Hut sign I was trying to create a situation where the meaning of the intervention was less determined, more absurd, and yet still reflected back onto the economic and aesthetic situation of the site. I suppose it could also be read in a more apocalyptic way, as though corporate globalization has even penetrated the island.

Jancou: And the hand-painted "ART SHOW" signs placed around the island?

Lieberman: Those are a kind of reversal of context. The gallery has a very professional, New York kind of feel, white walls and polished cement floors, as opposed to the other galleries on the island that take a much more rural approach. Many of them have similar hand-painted signs. Basically I wanted to turn the gallery into a Pizza Hut and then create the impression of a "local" art exhibition going on inside.

—JUSTIN LIEBERMAN, EXCERPTED FROM THE PRESS RELEASE OF THE EXHIBITION

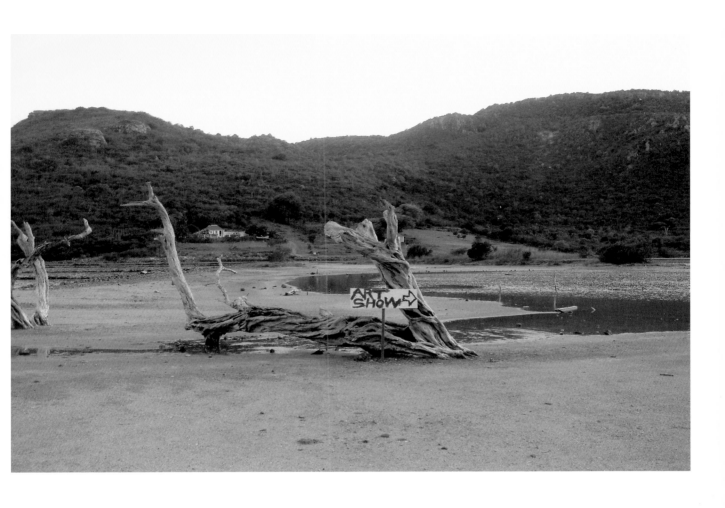

"THE PROSPERITY OF THE AUTHOR, THE MISFORTUNE OF THE PLAGIARIST"
2007

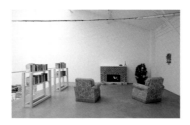

The first germ of the idea for many of the works in the exhibition *The Prosperity of the Author, the Misfortune of the Plagiarist* came in the form of what seemed to be the solutions to two problems I had been struggling with for quite some time: How to incorporate text into paintings without resorting to "poetry" (in the basest sense of this word), and how to create "gestural paintings" that carried none of the grandiosity and austerity inherent in the history of that medium. The solutions I arrived at, of course, carried with them their own set of sticky problems, which ultimately became the subject of the exhibition.

The problem of the incorporation of text in the paintings was attacked through the age-old method of quotation. I began screening my reading for paragraphs and phrases that contained a certain kind of ambiguous political rhetoric, exemplified by the text in *Painting for Life,* which was taken from an anti-abortion website where it was used as a rephrasing of a statement found on a pro-choice website to point out the original statement's hypocrisy. Or as in the painting *Eugenics and Society,* where the biologist Julian Huxley pleads the case in his pre-WWII essay of the same name for eugenics as a method for increasing the level of kindness and goodwill in the human race, a far cry from its actualization and assumed place in history.

I sought out phrases like these both for their pathos as well as their ambiguity. In pairing them with the images and painting methods that I did, I constantly bore in mind a particular series of gestural paintings by the Vienna Actionist Otto Muehl. The series, called *Politiker*, was done in the late 1980s, long after Muehl had seemingly closed the door on expressionist painting by carrying it through to its ultimate conclusion in the violent, bloody, sexual hysteria of his performances of the late 1960s and early 1970s. Viewed in this light, the *Politiker* series seemed to me to be a kind of resignation to the the failure of these earlier experiments in liberating the medium. Looking at these paintings, it occurred to me that transgression and freedom are possibly not the cardinal virtues they once had been. And so we are left with a kind of nostalgic pantomime of the act of transgression and artistic revolution. It is in this spirit that I sought out quotations and created the works for the exhibition.

The next problem was that this method of making paintings was a bit too easy for me. In practice, it seemed to present itself as a solution. A formula that could be endlessly repeated, ultimately becoming its own ideological stance and methodology. A success-ful experiment in good taste and common sense. So

where is the flaw? It is in that the paintings present themselves in terms of erudition and scholarship, leaning towards austerity and quality.

The other room was designed to "rectify" this problem and, in doing so, to inhabit the role of the secret shame of the exhibition. It is arranged as a small living area, with two comfortable chairs, a set of bookshelves, a fireplace, a plant, and a small clock on the wall. On each bookshelf is a row of books, which upon closer examination reveal themselves not to be books at all, but rather a painted plaster cast of a row of books, all of which are compendiums of quotations and chesnuts of popular wisdom. So the scholarship of the paintings was not scholarship at all, but rather its stunted younger sibling: an abridged version of real learning with none of the respectability and all of the efficacy.

In the painted cardboard fireplace is a video of a short play in nine acts which I have entitled *First Thought, Then Sustenance*. It is a structuralist narrative made in collaboration with the artists Jacques Vidal and Kembra Pfahler. It centers around three characters, a homeless man in a wheelchair, an SS officer, and a performance artist. The three characters are gathered around a flaming oil barrel and are engaged in the activity of tossing various books into the fire. They each have their own motivations for their participation in the book-burning: the artist burns the phone book, her own address book and finally the Bible, each with great ritual. The Nazi burns the works of Jewish intellectuals, and a copy of the Communist Manifesto. And the bum, burning books solely for the sake of warmth, mostly sticks to popular best-sellers, with the occasional book of Nietzsche or Picasso just to get his digs in at the other two.

The dialogue is composed entirely out of quotations from *Bartlett's*, ranging from Hamlet to Hitler. Each performer selected their own lines from the book in a kind of surrealist scriptwriting game. However, continuity was paramount here, and I hope this is visible in the way each line constitutes something between a response to the preceding line and a meandering pontification on the part of the speaker. This is the nature of the medium of quotation. It always has the flavor of a rambling conversation destroyer, a punctuation mark whose previously established authority makes any further discussion pointless. It can only be answered, of course, with another quotation.

—JUSTIN LIEBERMAN, EXCERPTED FROM THE PRESS RELEASE OF THE EXHIBITION

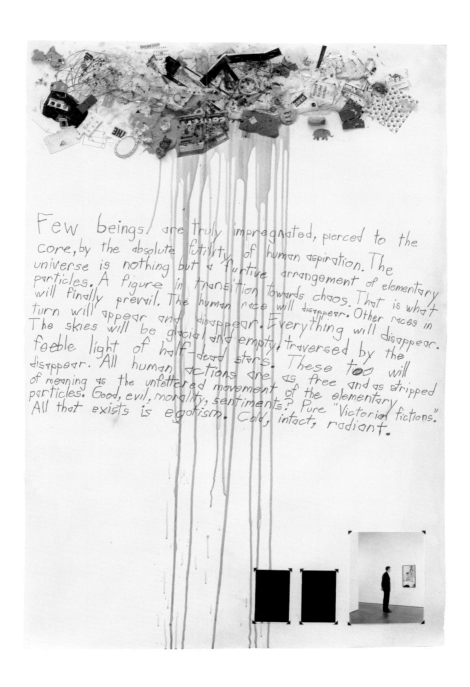

Few beings are truly impregnated, pierced to the core, by the absolute futility of human aspiration. The universe is nothing but a furtive arrangement of elementary particles. A figure in transition towards chaos. That is what will finally prevail. The human race will disappear. Other races in turn will appear and disappear. Everything will disappear. The skies will be glacial and empty, traversed by the feeble light of half-dead stars. These too will disappear. All human actions are as free and as stripped of meaning as the unfettered movement of the elementary particles. Good, evil, morality, sentiments? Pure "Victorian fictions." All that exists is egotism. Cold, intact, radiant.

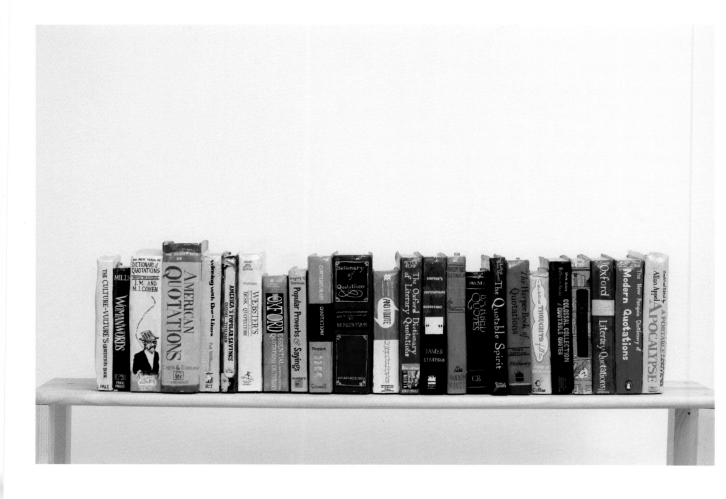

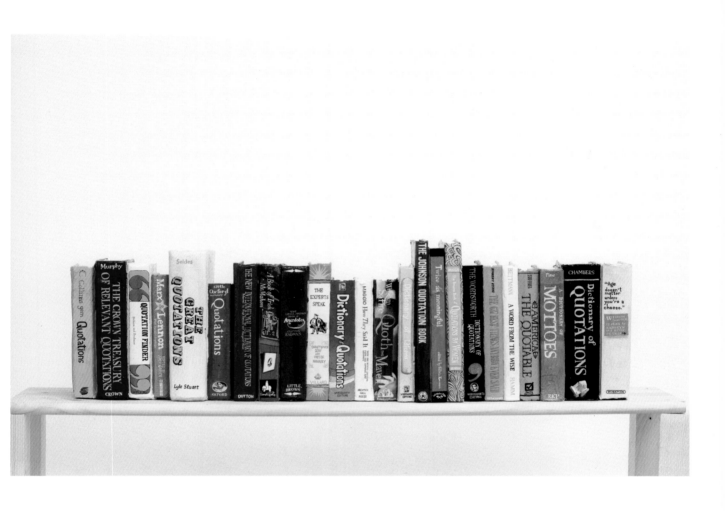

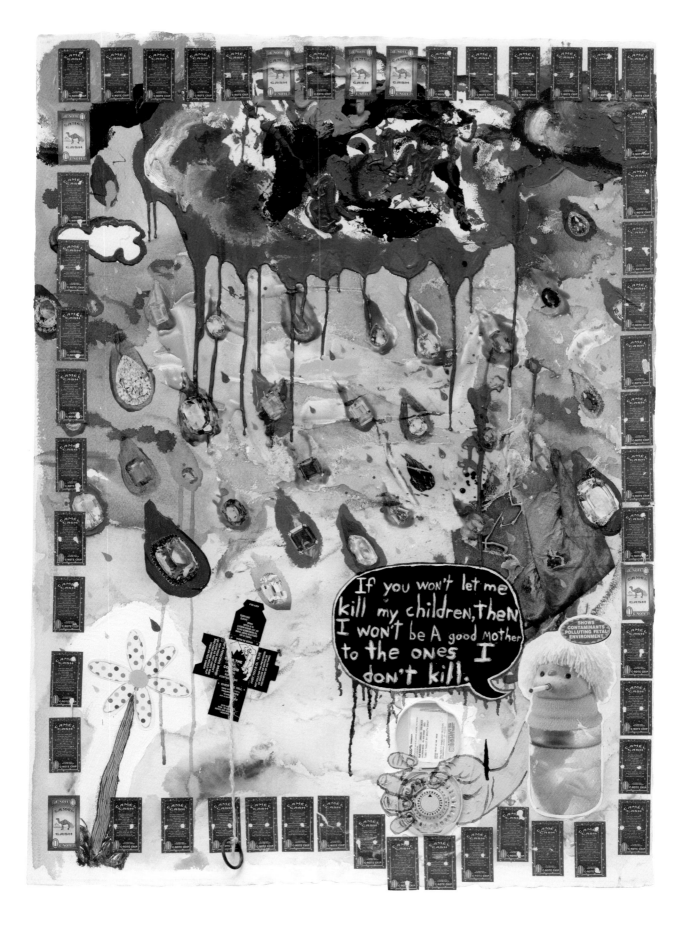

<div align="center">

"TIME AND MONEY"
2005

</div>

Time and Money (little slips of paper that float in and out of my life)

The installation is a work composed of discreet elements, which relate to each other both spatially within the gallery and conceptually through a network of implied equivalencies, narratives, and other more ephemeral associations.

Art in the Age of Mechanical Reproduction
The collage mosaics *Art in the Age of Mechanical Reproduction* treat their respective subjects in a manner according with the materials from which they are constructed: cards and leaflets. The collages were assembled like puzzles. No images were cropped or overlapped so their arrangement within the final pieces was done according to their size. Content and image played no role whatsoever (o.k. maybe a little bit) and so hierarchies of taste and quality are eliminated in random samplings of culture in both its purest (art) and most diluted (advertising) forms. From a regular viewing distance, this fundamental difference between the two pieces is nearly invisible, reducing itself to a minor visual detail questioning the hierarchy, which it clearly delineates.

The Far Side Calendar Time Machines
Memory and premonition come together and are depicted as equal forces within the context of *The Far Side Calendar Time Machines*. Meeting in the fleeting present represented by the exhibition itself, these sculptures might be seen as a study in planned obsolescence.

Zeroing in closely, we find that the days between March 23rd and April 23rd (the exhibition dates) are missing from the two-year period described by the time machines (2004-2006). This "missing time" constitutes the duration of the exhibition in which they were first presented and to which they will always in part be tied. The convoluted logic of these day/date correspondences mirrors in many ways the convoluted logic of time travel itself with all its inherent paradoxes.

The calendar pages themselves are taken from the Far Side Off-The-Wall Calendar from the years 1993, 1994, and 1995. The day/date correspondences of these years match those for the years 2004, 2005, and 2006, and the pages themselves are unmarked concerning the year that they are from. This creates a scenario in which the sculptures are specific to the time and place of the exhibition, however, on March 23rd of 2009 and 2011, the sculptures will again come into their own, in terms of synchronicity with the Christian calendar.

The calendars from 1993, 1994, and 1995 were procured from collectors on eBay in order to create a situation in which history's penchant for repeating itself is literally illustrated. Even a broken watch tells the correct time twice a day.

Please Try Again and *You Are Invited to a Party*
The collages *Please Try Again* and *You Are Invited to a Party* face each other from across the gallery alluding to optimism and pessimism. Or it might be more precise to say optimism and failed optimism. Hundreds of new invitations to parties not yet planned hold the promise of presents, new friends, free food, etc. The used-up lotto tickets have no such future. Their potential to bring financial gain or even momentary pleasure is spent.

The Box of Money
The inspiration for the box of money came from a proliferation of articles in the media concerning teenage counterfeiters creating currency on their home computers; a revolutionary act by default. The currency in the box is of a particularly poor quality as far as counterfeiting is concerned; much closer to the types of fake bills produced by drug addicts and teenagers than by a serious counterfeiter.

—JUSTIN LIEBERMAN, EXCERPTED FROM THE PRESS RELEASE OF THE EXHIBITION

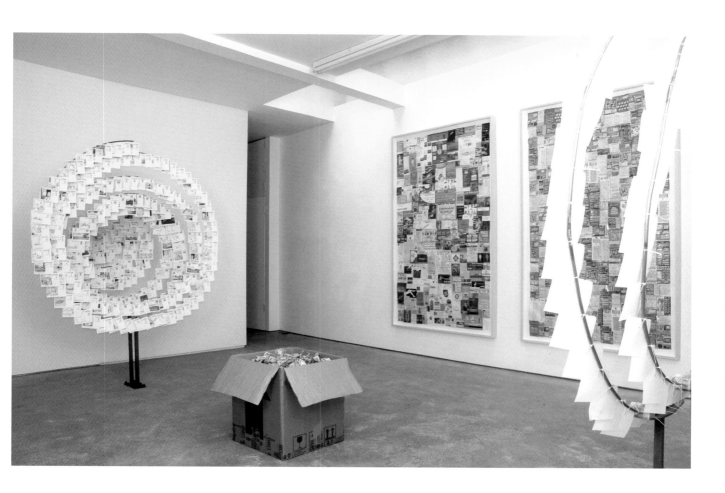

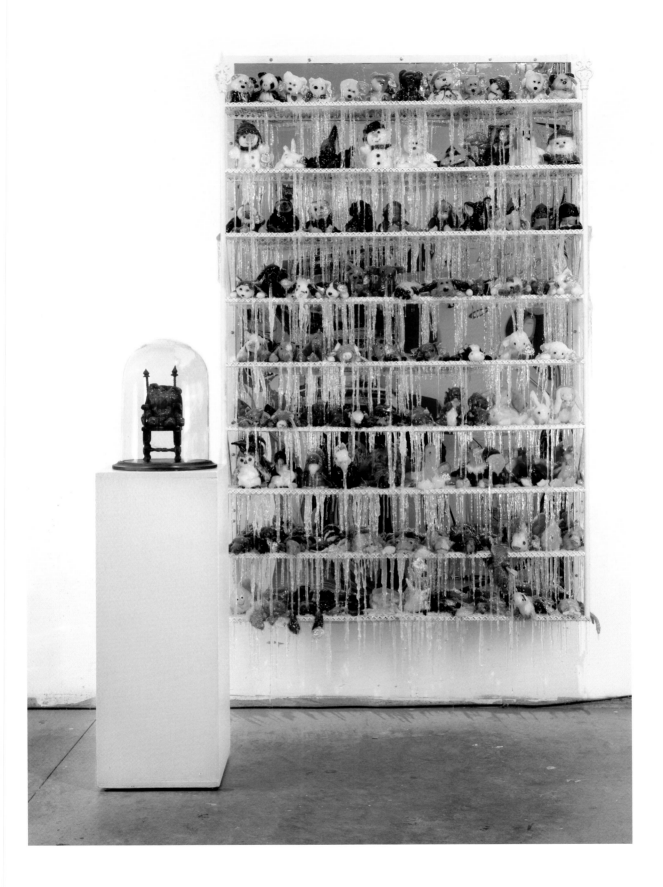

BEANIE BABY COLLECTION (EVOLUTIONARY SCALE) WITH LIMITED EDITION PRINCESS DIANA BEAR PLACEHOLDER, 2008

A Conversation with Justin Lieberman
Jacques Vidal

JACQUES VIDAL I've always wondered if your work comes directly out of language, as some of the references in the work imply (comic books, newspapers, song lyrics, and film). Is the direct appropriation of this type of information something that interests you especially, or is it that these sources provide you with a sort of freedom with which to operate creatively?

JUSTIN LIEBERMAN That is a complicated question. To the first part I would say Yes. The work usually does begin with language. That is to say a critical linguistic understanding of the subject matter. For instance, in the *Anaglyphic Works*, it is the idea of three-dimensional illusionism that is being explored rather than working with anaglyphic imagery in a traditional way. It has as much to do with the cultural associations one has with the medium as it does with the optical effects themselves. In general, the work is usually an illustration of an idea that takes into account the various relationships of the materials and methods to the idea itself. So there is a network of associations, comparisons, and analogies in place even before I even start. Those are the real materials that I am working with. The ambiguity comes afterward, in the various implications that can be derived. As far as appropriation goes, I don't think I'm really involved in that. What I do is much closer to collage. To me, appropriation is when an image or an object undergoes a shift in context without other changes or variables. I think that there is very little true appropriation that goes on in art. Most of what people refer to as appropriation is actually some form of collage. As far as the sources go, I use different things to explore different ideas. They vary.

JACQUES VIDAL Well, that's an even more complicated answer. I think the clarification between collage and appropriation is something we could expand on, but what I meant is, do these particular forms I mentioned (comics, fiction, song lyrics, etc) provide a model for the way you work? The authors in those fields are confronted with a different set of expectations and concerns than a gallery artist, so do their working methods provide a sense of freedom in your working method?

JUSTIN LIEBERMAN When I write fiction or song lyrics as part of an artwork, I DO make an attempt to deal with the standards of that medium. I tend to approach new mediums as an amateur, and attempt to acknowledge the rules inherent in that medium. In those cases, I am a fan. It's funny that you would use the term freedom, though. If anything, I would say the use of those techniques is about imposing different sets of rules onto the work, both in terms of its construction and its interpretation. I think that in the art world, despite its pretensions to openmindedness, there are expectations in place for art that is acceptable and art that is not.

Some of my ways of working fall outside of that realm. That is because they adhere to rule-based systems that are traditionally in the domain of other occupations whose proximity to the occupation of the artist is uncomfortably close. For instance, that of a designer or an illustrator. They inhibit people's ability to project their romantic notions of freedom onto the nature of what it means to be an artist. Because they are so banal. But they also reveal a potential for creativity in these roles. It's just that they do that without elevating or mystifying them.

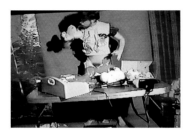

QVC, 1998

JACQUES VIDAL This reminds me of your garbage paintings. The presentation of those works seemed like a model for the elevation of materials and meaning that proposes to take place within art, like what goes on in the case of junk sculpture. You were working with this detritus, elevating it, putting little frilly frames on it, and mounting it onto stretchers. Creating successive framing systems around it. My point is, those works were certainly a diagram for the presentation of art, and specifically the presentation of a work of art made from debased materials. Are you some kind of salvage artist?

JUSTIN LIEBERMAN I never would have thought about it that way: that the show could be seen as an instructional guide for the care of works made of poor materials. For me, it was a way to demystify the process by which those types of works accrue meaning. The diagrammatic quality of those works was meant to reveal a system that was already in place. One that involves the conservation of deteriorating artworks. It began with the idea of cigarette butts falling off of Jackson Pollock's paintings. My paintings were only detritus, no paint at all, and there were troughs installed underneath the works to catch any that might fall off over time. I like the term "Salvage Artist" though. It implies a sympathy for the materials. When I was in art school I had a critique of my drawings in a painting class. One of the other students in the class, who made large expressionist paintings that were titled with quotations from Kafka, was really angry. He called my work "pity art" and stormed out of the room. I really liked that reaction. Total disgust from someone with high-minded ideals.

JACQUES VIDAL That is pretty good, actually. It sounds like one of those rare occurrences when the ideological scaffolding is inadvertently revealed. Are you in search of these structures?

JUSTIN LIEBERMAN There are certain pieces I have done which are meant to reveal ideological similarities, or possibly the similarities of all ideological doctrines. The tie-dyed *Klansfriends*, the hardcore logo coffee tables, and *Thank Heaven for Little Girls* were all deliberately iconoclastic in that way. Lately though, the work has become more centered around issues of taste and fashion. Because those are structures as well. But the frameworks for them are psychological rather than ideology-based.

JACQUES VIDAL In the anaglyphic pieces, specifically the three-dimensional wall relief work, and the feathers piece, were you looking at the antiquated technology of the old red and blue 3-D glasses as a kind of established logic? What I mean is: Did you see the 3-D effect as a closed logic

system, that could then be manipulated and expounded upon?

JUSTIN LIEBERMAN That is exactly the case. They used an inherently illusionistic medium to depict something which itself denounces illusionism: abstraction. The anaglyphic reliefs were an even further perversion of that logic. They were abstractions that were three-dimensional in real space. What is unique about that particular technology, though, is that it dealt specifically with visual perception and illusionism. Which brought it into the realm of art. Anaglyphic technology has been tried and failed so many times. Virtual Reality was basically just a more complex version of the red and blue 3-D glasses. Totally ignored. Nobody wants to wear something on their face for the sake of a visual experience. Because there is an element of performance in that. You can no longer maintain your objective distance. You become the subject. For my anaglyphic works it wasn't necessary to wear the glasses in order to experience the works.

QVC, 1998

JACQUES VIDAL I've noticed something I think is really particular to you. A lot of your works consist of an object, and a flat work framed next to it or adjacent to it, as in *Elegy*, which had a melting pig head paired with a newspaper clipping about a suicidal poet, or in the *Famous Aliens of Filmland and American Folk Furniture* show, where each painting was accompanied by a piece of furniture. I'm curious about the way you frame your work to be read like a domestic or corporate space. Where the objects arranged all seem to funnel into the presentation of your identity or your brand. This seems to me an extension of your predilection towards established structures, and also raises a fundamental question about the viewing of your work: Aside from the fact of its presentation in a gallery setting, is there anything in your mind that separates these art things from real things? Is there a logic you see that applies to your artwork that you couldn't readily apply to the design of a doctor's office?

JUSTIN LIEBERMAN I like established structures. I don't believe in an a priori experience of works of art. When I look at an artwork, the first thing that comes into my mind is the other artworks it reminds me of. So inevitably, most art inhabits the structures that have been previously established by earlier works of art. My work inhabits those structures too, but it deliberately confuses them with other structures. The gallery setting is extremely important to my work. Some of the works, like the *Sound Dampening Modular Room Dividers* from the *Agency* show, would almost disappear without that context. It's also very important to me that it be considered as art and not as something else that just happens to be in a gallery, like the props from Michel Gondry's films at Deitch Projects or *The Art of the Motorcycle* at the Guggenheim. I don't think of my work as blurring the boundaries between art and life, or art and design. Like all art, it is a completely useless artificial construct. That said, given carte blanche, I would love to design a doctor's office.

JACQUES VIDAL I don't think that you really believe that art is useless, although I can see how it fits into your creative process. You are a collector, of art, of artifacts, clippings, films, records, etc. Which is

what makes your newest body of work (*The Corrector*) seem so full of use for you on a very basic level. It is true that the way a work of art functions in a gallery is continually being revised, but your work seems to go out of its way to assume or propose some new or unconventional functions even in that realm. I'm thinking specifically about *Kurt Russell: RE-GENESIS*, and the *Pizza Hut Sign* from *Grand Opening*. Really, almost everything seems to propose a new use-value for artworks, even if that new use-value is typically subversive, or absurdly specific to you.

JUSTIN LIEBERMAN I think that it is precisely the lack of a use-value that defines art and gives it its incredible power and potential. When art becomes useful it becomes banal, either propaganda or design. I love good art. I try to make art that I think is beautiful and expresses something important and profound.

JACQUES VIDAL I questioned your statement about "art being useless" because I've always liked how your work produces a collapse of the semantic structures that superimpose meaning onto artworks.

JUSTIN LIEBERMAN I believe that the language that surrounds an artwork is what determines the way in which it is interpreted. That is why I write about my own works. But I like the idea that the work has the capability to communicate directly without the aid of language. There is a point where language becomes more of a hindrance than a help. It's just that my works aren't racing to reach that point. I don't want to elicit confusion as an initial reaction. I don't like art that strives for ambiguity at the outset. I want there to be a point at which people think they understand the work. Jokes function in a similar way. That is why many of the works share certain characteristics with them.

JACQUES VIDAL It would be too easy to think that your work was simply about language, and about a sort of sub-cultural American narrative. I think your craft is in locating places in which highly charged cultural signifiers can merge in unexpected ways. *Klansfriends* is the obvious example. It's not really an ideological clash that's being represented. It seems more like an ideological drain. What draws you to that particular dynamic?

QVC, 1998

JUSTIN LIEBERMAN I think that merging happens all the time. Particularly in the world of fashion, where "chic" is a suffix that can be stuck on the end of almost everything. Every imaginable subculture is now quickly consumed by fashion and just as quickly evacuated of its meaning through the application of successive layers of "retro." I find that repulsive. There is a crucial difference, which is that in my work, the signs retain their meaning. If they didn't, the work would just be deploying loaded symbols for the sake of shock value. I try to choose subjects that contain a lot of built-in rhetoric and then derail that rhetoric and aim it at different targets. The whole point is that aesthetic and moral judgements become conflated and confused. Not in an overly determined moralistic way (because it is not activism), but in a weird, free-floating, "Wait, Did I just think that?!?!" kind of way. It is about the ways in which taste, morality, and perception are bound up together. That the work is fundamentally

disorienting to those senses. The synaesthesia of those senses. "I like," "I believe," and "I see," all start to blend together when you try to follow the narratives.

JACQUES VIDAL In the *Agency* show, you carefully fulfilled the requirements of advertising, but also addressed their debased status as a medium of mass-consumption. In the *Lexapro*, and *Manhattan Mini Storage* ads, you were happily lecturing in the vocabulary of quick, clear product endorsements, "something snappy" as they say in *The Hudsucker Proxy*, but you were also insisting upon the delicate handling of the medium as an identity politic. It's as though the show was an inside joke made for those in the world of advertising. The *Fan Fictions* could be read in exactly the same way relative to the world of comics and science-fiction. It reminds me of an essay by Joe Scanlan,[1] where he describes artistic production as a form of niche marketing, akin to selling *Star Wars* figures on eBay.

JUSTIN LIEBERMAN I know the essay. He goes on to describe the objective of the enterprise as being one in which an extremely particular craft is refined to the point where it is of the absolute highest quality in its field, thus dominating its particular niche. It would be perverse to think of my ads or fan fictions as being the highest quality in those fields. Clearly they are not. The standards of quality they subscribe to are of an entirely different nature. In terms of the identity issue, I would say that when making those works, I am sympathetic to the occupation. I am on their side. The ads in *Agency* weren't meant to be a situationist *dérive*. I don't believe that that kind of messaging means anything now. It has been converted into guerrilla marketing. Those ads were my attempt to speak in that language. I wasn't mocking it. I was attempting to participate. Each one of those ads endorsed a product that I use all the time. People expect fury at advertising from artists and so they project that onto any artwork that deals with the subject. I do think that my work fills a small niche market within the art world. I suppose that niche is composed of individuals much like myself.

JACQUES VIDAL I suppose it is.

JUSTIN LIEBERMAN Trust me, it is.

1
Joe Scanlan, "People In Trade."
Art Issues, January 2001.

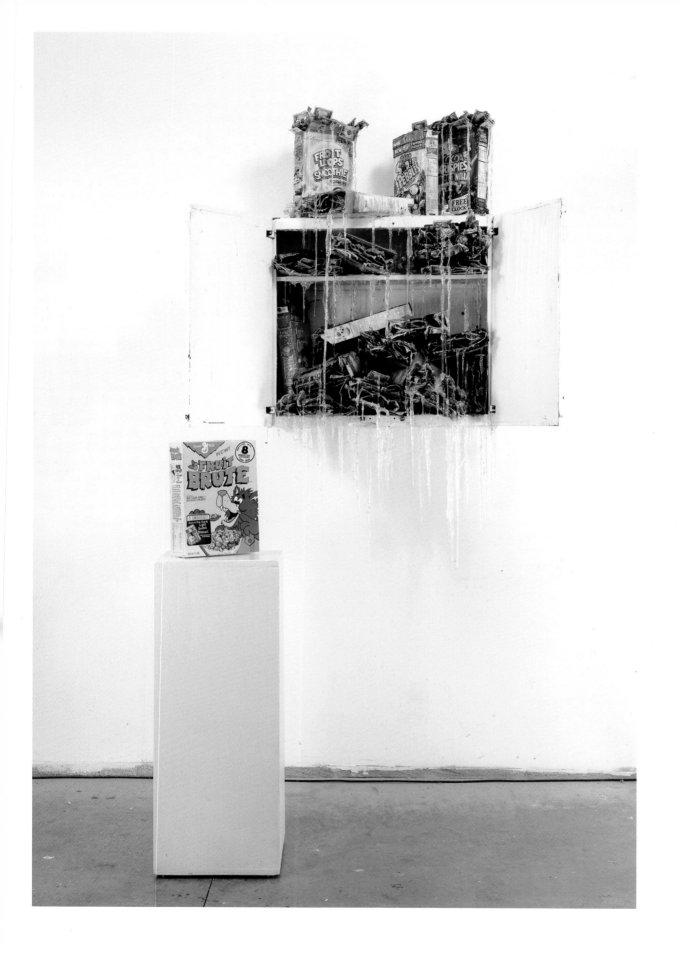

CEREAL BOX COLLECTION FOR PHILIP TRAVERS WITH FRUIT BRUTE PLACEHOLDER, 2008

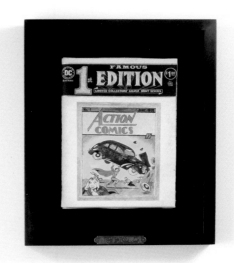

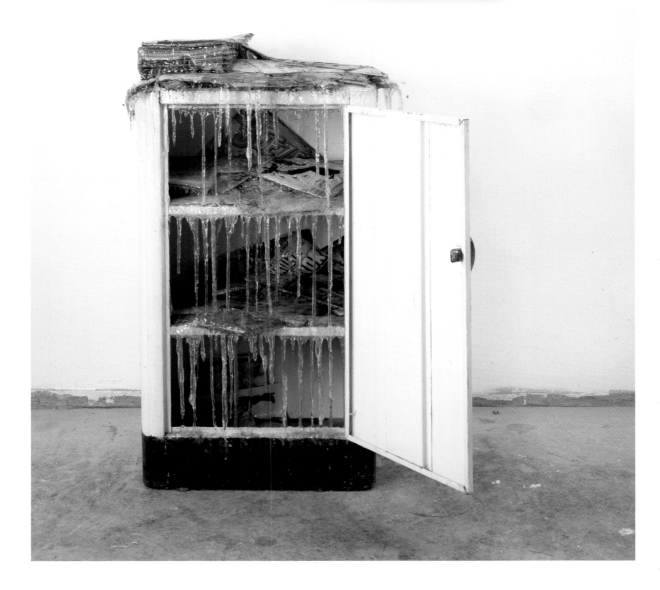

PLATONIC HIERARCHY OF COMIC BOOKS WITH ACTION COMICS #1 REPRINT PLACEHOLDER, 2007

List of Illustrations

[p. 46] ANNALS OF HISTORY I, 2005
FGR95, oil paint with acrylic basecoat, 94 x 24.8 x 15.9 cm
Courtesy of Sutton Lane, London

[p. 47] ANNALS OF HISTORY II, 2005
FGR95, oil paint with acrylic basecoat, 94 x 24.8 x 15.9 cm
Courtesy of Sutton Lane, London

[p. 49] PAINTING FOR LIFE, 2005
Mixed media on paper, 106.7 x 76.2 cm
Courtesy of Sutton Lane, London

[p. 51] Installation view, TIME AND MONEY, 2005
Sutton Lane, London, March 23–April 23, 2005

[p. 52] BEANIE BABY COLLECTION (EVOLUTIONARY SCALE)
WITH LIMITED EDITION PRINCESS DIANA BEAR
PLACEHOLDER, 2008
Mixed media, 223.5 x 127 x 30.5 cm; 39.4 x 30.5 x 30.5 cm
Courtesy of Zach Feuer Gallery, New York

[p. 54, 55, 56] QVC, 1998
Still from video performance on VHS film, 22 minutes
Courtesy of the artist

[p. 58] CEREAL BOX COLLECTION FOR PHILIP TRAVERS
WITH FRUIT BRUTE PLACEHOLDER, 2008
Mixed media, 167.4 x 76.2 x 48.3 cm; 34.3 x 24.1 x 7.6 cm
Courtesy of Zach Feuer Gallery, New York

[p. 59] PLATONIC HIERARCHY OF COMIC BOOKS WITH
ACTION COMICS #1 REPRINT PLACEHOLDER, 2007
Mixed media, 92.7 x 80 x 40.6 cm; 44.45 x 35.6 cm
Courtesy of Zach Feuer Gallery, New York

[p. 64] Detail of CEREAL BOX COLLECTION FOR
PHILIP TRAVERS WITH FRUIT BRUTE PLACEHOLDER, 2008
Courtesy of Zach Feuer Gallery, New York

Biography/Bibliography

Born 1977, Gainesville, FL
Lives and works in Chatham, New York

SOLO EXHIBITIONS

2009

The Corrector in the High Castle, Zach Feuer Gallery,
New York
The Corrector Custom Pre-Fab House, Marc Jancou
Contemporary, New York

2008

Fan Fictions and Anaglyphic Works, Patricia Low
Contemporary, Gstaad
*The Destruction of Everything There Is, The Beast of
Judgement at the End of Life, All-Encompassing
All Devouring Entropy at the End of Everything,*
Limoncello, London
*Famous Aliens of Filmland & American Folk Furniture
Originals by Justin Lieberman,* Galerie Rodolphe
Janssen, Brussels

2007

Ebony, Ivory, Rubber & Dough, Sutton Lane, London
Kurt Russell: RE-GENESIS, Kavi Gupta Gallery, Chicago
Self-Portraits, McCaffrey Fine Art, New York
Agency (Open House), Zach Feuer Gallery, New York
A Place for Everything and Everything in its Place,
Kantor/Feuer Gallery, Los Angeles

2006

Cultural Exchange, Sorry We're Closed, Brussels
Grand Opening!!! Me.di.um, St. Barth
*The Prosperity of the Author, The Misfortune of the
Plagiarist,* Sutton Lane, Paris

2005

The Appendectomy Benefit, Locust Projects, Miami
Reflection Part II, Sutton Lane, London c/o Galerie
Ghislaine Hussenot, Paris

2004

Folk Art Is the Work of Satisfied Slaves, LFL Gallery,
New York

2002

Justin Lieberman: The Dishwasher's Song, Oni Gallery,
Boston
Justin Lieberman, Allston Skirt Gallery, Boston

GROUP EXHIBITIONS
(SELECTION FROM 2005)

2008

Agency: Art and Advertising, McDonough Museum of Art,
Youngstown
Heroes and Villains, Marc Jancou Contemporary, New York
Faces and Figures (Revisited), Marc Jancou Contemporary,
New York
Political Corect, BFAS Blondeau Fine Art Services, Geneva
Jekyll Island, Honor Fraser, Los Angeles
Tonight Forget About Your Cars and Houses, Union Gallery,
London
Darger-ism: Contemporary Artists and Henry Darger,
American Folk Art Museum, New York
In Geneva No One Can Hear You Scream, Blondeau Fine Art
Services, Geneva
In the beginning, University Art Gallery, University of
California, San Diego

2007

Fit to Print, Gagosian Gallery, New York
Post Retro, Brooklyn Fireproof, Brooklyn

Some Kind of Portrait, Marc Selwyn Gallery, Los Angeles
NeoIntegrity, Derek Eller Gallery, New York
Distinctive Messengers, House of Campari, Los Angeles
Fung Wah, Howard Yezerski Gallery, Boston

2006

25 Bold Moves, House of Campari, New York

2005

Helter Skelter, Capsule, New York
Post-Everything, The Rotunda Gallery, Brooklyn
Exploding Plastic Inevitable, Bergdorf Goodman, New York
Sutton Lane in Paris, Sutton Lane c/o Galerie Ghislaine
Hussenot, Paris

BIBLIOGRAPHY

2008

[Ed.], "Words of Art: Feuer Burns Hot," *Gotham,* December
2007–January 2008
Allsop, Laura. Green, Jessika. "Consumed," *Art Review,*
April
Johnson, Ken, "An Insider Perspective on an Outsider
Artist," *The New York Times,* April 18
Halle, Howard, "Dargerism: Contemporary Artists and
Henry Darger," *Time Out New York,* April 24–30
Falconer, Morgan, "Zach Feuer," *Art World,* April/May,
p. 128–129
Jancou, Marc, [ed.], *In Geneva No One Can Hear You
Scream,* JRP|Ringier, Zurich

2007

Lieberman, Chuck, "Belgian Waffles draw Chuck and wife
overseas," *Watauga Democrat,* January 22
Wolin, Joseph R., "Justin Lieberman," *Time Out New York,*
February 7–15
[Ed.], "Bright Young Things," *New York Magazine,* February
12, p. 90
Rosenberg, Karen, "An Afternoon in Chelsea," *New York
Magazine,* February 12
Gelber, Eric, "Arts in Brief," *The New York Sun,* February
15, p. 17
[Ed.], "Justin Lieberman," *The New Yorker,* February 26
Gelber, Eric, "Justin Lieberman: Agency (Open House),"
Artcritical.com, April
Lieberman, Chuck, "Prodigal Son Shines with Aplomb,"
Watauga Democrat, April 2
[Ed.], "The NADA Emerging Artists Page," *The L Magazine,*
July 18–31, p. 80–81
Lopez, Ruth, "Justin Lieberman," *Time Out Chicago,* August
9–15
Coomer, Martin, "Funny Noises at Brown Gallery," *Time Out
London,* August 10
Woods, Kelly, "King of the One-Liners," *Useless #6,*
September, p. 31
Lieberman, Justin and Vidal, Jacques, "Justin Lieberman
talks to Jacques Louis Vidal," *NY Arts,* November
December, p. 44–45

2006

[Ed.], "built to sell?" *Nylon,* April, p. 73
[Ed.], "Envies de voir," *Weekend,* September

2005

Williams, Eliza, "Justin Lieberman," *ArtReview,* June
[Ed.], "Emerging Artists," *Art Matters,* Fall, p. 9
Kleinman, Adam, "Litter and Glitter," *artnet.com,*
December 14

2004

[Ed.], "Galerien National," *Der Standard,* July 15, p. 10

This book was published on the occasion of the exhibitions *The Corrector Custom Pre-Fab House*, at Marc Jancou Contemporary, January 15–February 21, 2009, and *The Corrector in the High Castle* at Zach Feuer Gallery, January 31–March 7, 2009.

MARC JANCOU CONTEMPORARY
Great Jones Alley
New York, NY 10012
USA

ZACH FEUER GALLERY
530 West 24th Street
New York, NY 10011
USA

The publication has received generous support from:
Bernier/Eliades Gallery, Athens
BFAS Blondeau Fine Art Services, Geneva
Galerie Rodolphe Janssen, Brussels
Sutton Lane, London and Paris

PUBLICATION

EDITOR Lionel Bovier
EDITORIAL COORDINATION Birte Theiler, Kelly Woods
PROOFREADING Kelly Woods, Louise Stein
DESIGN no-do
TYPEFACE Hermes Sans (www.optimo.ch)
PHOTO CREDITS Boru O'Brien O'Connell, Andy Keate,
Philippe D. Photography, Raphaël Faux, Adam Reich,
Jason Mandella
COLOUR SEPARATION AND PRINT Musumeci S.p.A. (Aosta)

Printed in Europe.

PUBLISHED BY
JRP|Ringier
Letzigraben 134
CH-8047 Zürich
T +41 (0)43 311 27 50
F +41 (0)43 311 27 51
www.jrp-ringier.com
info@jrp-ringier.com

ISBN 978-3-03764-008-1

JRP|Ringier books are available internationally at selected
bookstores and from the following distribution partners:

SWITZERLAND
Buch 2000, AVA Verlagsauslieferung AG, Centralweg 16,
CH-8910 Affoltern a.A., buch2000@ava.ch, www.ava.ch

FRANCE
Les Presses du réel, 35 rue Colson, F-21000 Dijon,
info@lespressesdureel.com, www.lespressesdureel.com

GERMANY AND AUSTRIA
Vice Versa Vertrieb, Immanuelkirchstrasse 12,
D-10405 Berlin, info@vice-versa-vertrieb.de,
www.vice-versa-vertrieb.de

UK AND OTHER EUROPEAN COUNTRIES
Cornerhouse Publications, 70 Oxford Street,
UK-Manchester M1 5NH, publications@cornerhouse.org,
www.cornerhouse.org/books

USA, CANADA, ASIA, AND AUSTRALIA
D.A.P./Distributed Art Publishers, 155 Sixth Avenue,
2nd Floor, USA-New York, NY 10013, dap@dapinc.com,
www.artbook.com

For a list of our partner bookshops or for any
general questions, please contact JRP|Ringier directly
at info@jrp-ringier.com, or visit our homepage
www.jrp-ringier.com for further information about
our program.

INSIDE! 1 Fruit Brute
Glow-in-the-Dark
Light Switch Sticker

FRUIT BRUTE SAYS When you leave turn the lights OFF!

KEEP THIS LIGHT OFF! SAVE ENERGY!

Fruit Brute Glow-in-the-Dark Light Switch Stickers, with energy saver messages! Just peel off the back and stick 'em over the light switch plates in your room! • Helps you find the light switch when it's dark! Helps remind you to turn off the lights when you don't need them! • Collect all six different Glow-in-the-Dark Light Switch Stickers. They'll look great on your walls and door! • Sticker size: 2¼" x 3½".

BIG G CEREALS AND MILK... PARTNERS IN GOOD NUTRITION

Big G Cereals and Milk add more nutrition in many ways.

Milk is an excellent source of nutrition. And Big G Cereals add more nutrition in many ways.

1 FRUIT BRUTE adds iron.
Milk is a poor source of iron, but a one ounce serving of Fruit Brute and milk supplies 25% of your day's iron requirements.

2. FRUIT BRUTE contributes five B vitamins.
A one ounce serving of Fruit Brute and milk provides at least 25% of your daily needs of thiamin (B₁), riboflavin (B₂), niacin, B₆, and B₁₂.

3. FRUIT BRUTE supplies Vitamins A and C.
A one ounce serving of Fruit Brute and milk supplies at least 25% of your days need for these two vitamins.

4. FRUIT BRUTE and milk provide protein.
A one ounce serving of Fruit Brute and 4 oz. of milk provide 8% of your daily needs of protein.

Fruit Brute and milk furnish all these nutrients. Together they supply you with at least 25% of the U.S. RDAs of 8 Vitamins and Iron now set by the U.S. Government.

U.S. RECOMMENDED DAILY ALLOWANCES *
FRUIT BRUTE ■ MILK □

U.S. RDA		
40%		
60%		
20%		
10%		

PROTEIN VITAMIN A VITAMIN C THIAMIN RIBOFLAVIN NIACIN CALCIUM IRON VITAMIN D VITAMIN B₆ VITAMIN B₁₂

* Provided by a normal serving of Fruit Brute (1 Oz. or 1 Cup) and ½ cup of Vitamin D Whole Milk.